art maps

How to Paint Watercolors Filled with Bright Color

by Dona Abbott

international
artist

International Artist Publishing, Inc
2775 Old Highway 40
P.O. Box 1450
Verdi, Nevada 89439

Most photos courtesy of Bill Ervin
Edited by Jennifer King
and Terri Dodd
Design by Vincent Miller
Typesetting by Nicolas Vitori and Cara Herald

ISBN 1-929834-48-9

Printed in Hong Kong
First printed in hardcover 2004
08 07 06 05 04 6 5 4 3 2 1

Distributed to the trade and art markets
in North America by:
North Light Books,
an imprint of F&W Publications, Inc.
4700 East Galbraith Road
Cincinnati, OH 45236
(800) 289-0963

Copyright warning!

Contents

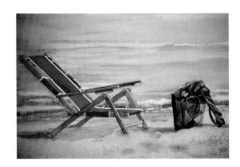
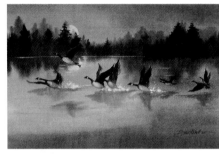
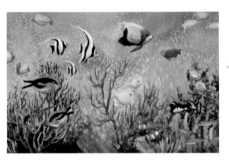
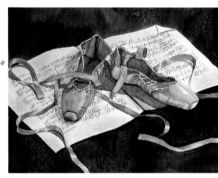

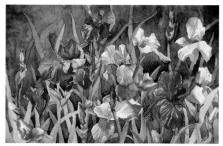

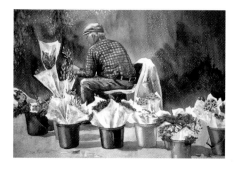

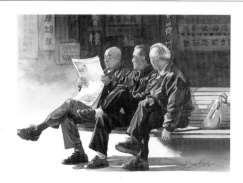

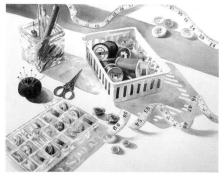

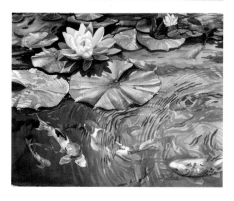

About the artist

As a child growing up on the southern Illinois prairie, Dona Abbott developed an early interest in nature and art. She would sit for hours sketching chalk images on an old slate, a perpetual cloud of chalk dust surrounding her. She made good use of her time as she recuperated from polio.

Discovering the West was in her blood, she studied art, archaeology and anthropology in New Mexico before settling in Colorado in 1965.

She graduated from the Famous Artists Schools, holds a BA from the University of Colorado and spent 37 years in the corporate world, designing decorative packaging and promotional programs as a vice president of advertising and design. Simultaneously, she kept her fine arts interests alive by studying with many well-known artists. She devoted several years to working in line and value, developing a strong foundation in drawing before moving on to watercolor. For 18 years, she was a partner in the Mustard Seed Gallery, Boulder, Colorado's oldest established gallery.

Dona's subjects range as widely as her interests — from a vegetable market in Vietnam to a sunrise over a Rocky Mountain lake. Yet all play soft, gentle washes against crisp lines. She uses the luminosity of transparent watercolor to capture the constantly changing hues of nature, from the play of evening light across a landscape to the subtle contrasts in a subject's face. Rather than trumpeting the exotic, her paintings celebrate the poetry that underlies the ordinary things we too often take for granted. By changing a viewpoint, emphasizing a particular feature or orchestrating a careful juxtaposition of elements, the viewer is urged to a new perspective. Dona's art reinforces the connections between people and celebrates her reverence for life.

"I see strength in simplicity and feel a spirit of peace in appreciating that simplicity," Dona says. "I don't believe that art has to be some tortured expression to be valid. By focusing on what is good and positive in humanity and the world, I somehow touch and reaffirm what is best in myself.

"Life and art are intricately interwoven until they seem inseparable to me," she adds. "Beauty and grace are all around us. We need only open our eyes to it. Capturing that by creating a work of art is a self-renewing experience. It's an affirmation of life. I feel I've succeeded if my painting can convey the sense of joy I feel whenever I touch my brush to the watercolor paper."

Dona's work appears in national and international juried shows. She has exhibited in many galleries and is often asked to teach and serve as a juror. Her paintings have been included in *100 Ways to Paint People & Figures,* published by International Artist Publishing and in the December/January 2004 issue of *International Artist* magazine. She is a member of the Transparent Watercolor Society of America, Watercolor West and Foothills Art Center.

Her work can be seen at Max'ims of Greeley and by appointment at her studio: 2855 Iliff St., Boulder, CO 80305. You can see more of her originals and limited-edition prints or contact her through e-mail on her website: http://members.aol.com/dabbott303

DEDICATION
This book is dedicated to Lon and Tasha who have filled my life with meaning and joy; to my grandchildren, whose fresh innocence reminds me that life is filled with possibility, and to Bill, who wraps me in a circle of understanding and love.

ACKNOWLEDGMENTS
To Vincent Miller and Terri Dodd for suggesting this book and giving me a chance to share a very important part of myself. To Jan, Mary Kay and Wanda, who believed in me and collected my work from the very beginning. To Bill Ervin for faithfully capturing my work in photography for this book. To artist friends and instructors, who share my passion for watercolor. And last, but not least, to the beauty that surrounds us and provides unlimited inspiration.

Introduction

Transparent watercolor has been my challenge and my solace since 1968. Not only has this quick-drying medium been a pleasure to use, I've found it to have clarity and spirit. It's a medium that definitely has a mind of its own.

Watercolor never ceases to surprise and fascinate. It has a staggering range of potential, and I sincerely enjoy directing the medium to express the things I want to say.

Perhaps the unique quality I love most about transparent watercolor is the way light passes through the colored pigments, bouncing off the white paper to produce a luminosity that vibrates with life. There is no other medium I know that works in quite the same way. Transparent watercolor is fresh — the pigments are like precious jewels, and that is the beauty of working with it, as I hope you will discover in this book.

Materials you will need to paint every project in this book

Paint

It is important to use artist's quality materials if you want to achieve optimum results. Student's quality paint is cheaper, but because it contains extenders, the colors are generally weaker. Pure pigment artist quality paints tend to be more transparent and they are better in every way, from strength of color to mixing capability.

Get to know your paints because some pigments are opaque, some are transparent. It's no good putting an opaque paint over a passage that you want to be translucent. In this book you'll see that I refer to color temperature — the warmth (redness) or coolness (blueness) of a color. Make an effort to understand the implications of this because it is important. As well, some pigments have a mottled, granulated effect, which might be just what you want in some cases, and a no-no in others. And, some pigments are so intense that you have to use them sparingly. You have to experiment to find how they behave, how they mix and how they work best for different subjects.

Paper

Paper manufacturers have spent decades developing different papers especially for artists. Everything, from the size used in the manufacture, to fiber content and degree of smoothness and roughness, has been carefully formulated to give you the best surfaces possible to help you control the pigment flow. Using cheap paper is the worst thing you can do because the paint won't flow, it'll bleed everywhere like blotting paper, you won't be able to achieve lifting effects and the pigment will even slide off the surface.

I recommend 300lb (638 gsm) or 140lb (300 gsm) cold-pressed watercolor paper paper for these projects.

Brushes

Brushes are equally important to the success of watercolor. You want brushes that hold lots of pigment so you can lay down washes without having to keep lifting and reloading with more pigment, spoiling the effect you've just applied. For detail work you need brushes that can hold an extremely fine point. A cheap brush will not last long, whereas a quality brush will last for years, even with daily use.

Sable and squirrel brushes are traditionally the best, but if you don't want to use animal hair, modern soft synthetic brushes are very good. Simply buy the best brushes you can afford because they produce the most satisfying mark and quickly spring back into shape after use.

Watercolor paint

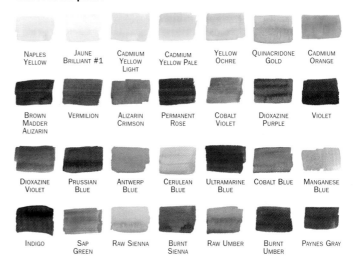

NAPLES YELLOW · JAUNE BRILLIANT #1 · CADMIUM YELLOW LIGHT · CADMIUM YELLOW PALE · YELLOW OCHRE · QUINACRIDONE GOLD · CADMIUM ORANGE

BROWN MADDER ALIZARIN · VERMILION · ALIZARIN CRIMSON · PERMANENT ROSE · COBALT VIOLET · DIOXAZINE PURPLE · VIOLET

DIOXAZINE VIOLET · PRUSSIAN BLUE · ANTWERP BLUE · CERULEAN BLUE · ULTRAMARINE BLUE · COBALT BLUE · MANGANESE BLUE

INDIGO · SAP GREEN · RAW SIENNA · BURNT SIENNA · RAW UMBER · BURNT UMBER · PAYNES GRAY

Other materials
- old toothbrush
- liquid masking fluid
- 2B pencil
- facial tissues
- spool of thread
- rubber band
- rubber cement pick-up
- spritzer bottle filled with water
- natural sponge
- coarse salt
- table salt
- pen stylus
- eraser
- paper towels
- Hairdryer

Brushes
- ¼", 1", 2" or 3" flat
- nos. 4, 6, 8, 12 and 20 round brushes
- grass comb (a special brush with separated hairs)
- fan brush
- ¾" oval wash
- rigger or script brush
- no. 2 square-tipped brush
- small bristle brush

Paper
- 300lb (638 gsm) or 140lb (300 gsm) cold-pressed watercolor paper

art map 1

Painting with vibrant color

Before you begin, read the entire project through so you know what's going to happen next.

While walking along the beach, I was struck by the intensely brilliant color of a beach chair and towel, and the contrast they presented against the natural colors of sea and sand. It spoke to me of a delightful afternoon at the beach.

This is typical of how many of my paintings begin. As I go through my day, I am often struck by the beauty of little still lifes that occur naturally at the most unexpected moments and places. As artists, it's important to remain open and alert to these things when they present themselves because just noticing them adds depth and richness to life. You may find yourself attracted to the way light falls over objects or to a chance arrangement of items. If you make it a habit to notice such things, soon you will find yourself seeing potential paintings everywhere you go.

When I was ready to paint, I decided I wanted my painting to evoke the sound of laughter, the feel of warm sun and gentle breezes, the sound of the waves coming onto shore and the invigorating scent of the sea. Many of these sensations come from the wonderfully intense colors throughout the piece.

It was a happy painting to do, and I relished watching the rich watercolor pigments flow onto my paper.

I think this is a great project for you to start with. Take your time, and enjoy the process of watching the absolutely vibrant transparent watercolors move over your paper. You'll also have a chance to practice creating textures, such as the gentle waves and the basket's woven surface. Have fun!

1. The image to be transferred using the art map.

Read the instructions to see how to map this image across to your paper.

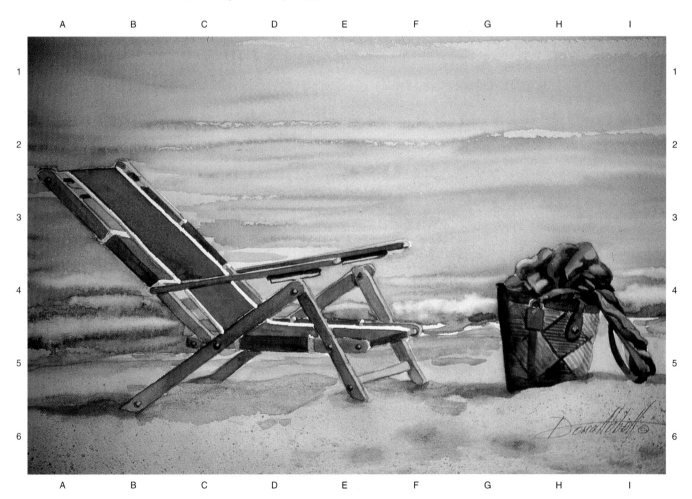

2. Map the image

With a 2B pencil, begin by LIGHTLY drawing a grid on your paper that has the exact same number of squares as my grid. Your paper can be the size of my original, or you can choose something proportionally larger or smaller. Here, your art map will have 6 squares down and 9 squares across. Put in the letters and numbers along the edges to make the next step easier.

3. Use the art map to transfer the image

Now, still drawing very LIGHTLY with your pencil, copy the main contour lines of the objects as shown in each square onto your watercolor paper. It's not necessary to get every detail — just a simple line drawing will do. I recommend LIGHTLY and gently erasing the grid lines in the open, lighter areas before continuing.

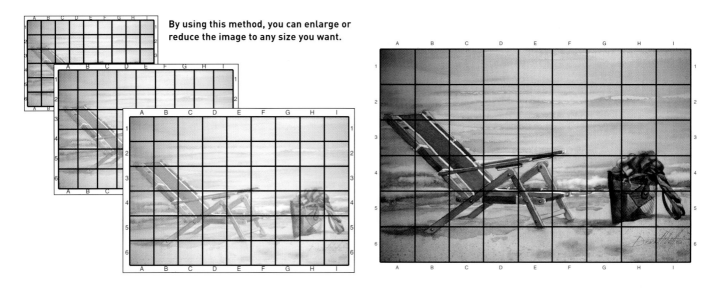

By using this method, you can enlarge or reduce the image to any size you want.

This is how your art map should look.

Here I've done the drawing quite heavily so you can see the idea, but you will do this lightly in pencil.

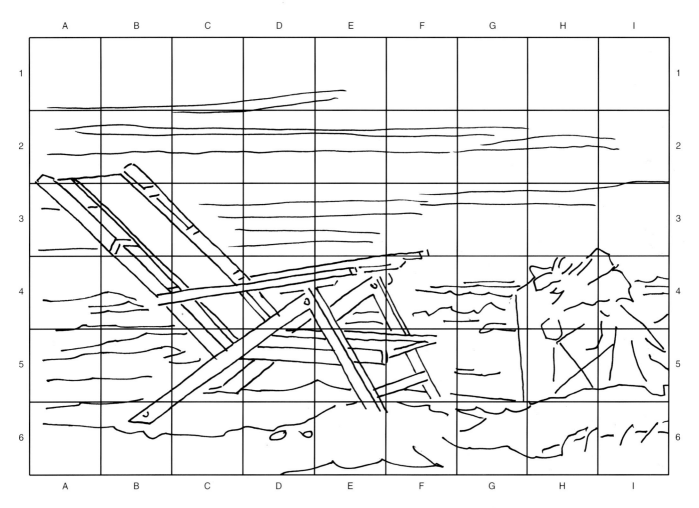

Study these pages before you start painting

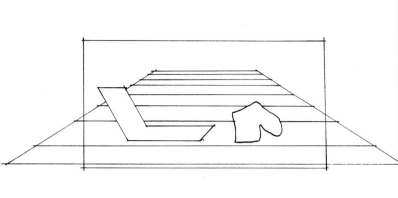

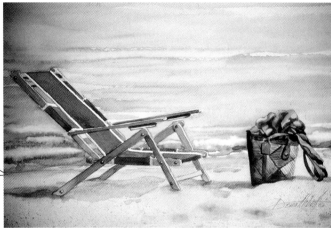

Design map
This composition plays horizontal lines against angular shapes. The predominantly horizontal lines of the waves, shadows and sand, as well as the elongated horizontal format of the overall painting, create a feeling of peace and calm. The chair and basket stand out, not just because they have vibrant color but also because they break the flow of the horizontals.

Tonal value map
Learning to see the tonal values — the lightness and darkness of the colors — is essential. In this black-and-white version of the painting, you can see how I arranged the values with a purpose. I put the lighter values toward the center to keep the eye moving within the painting, and used darker values toward the edges to stop the eye from leaving.

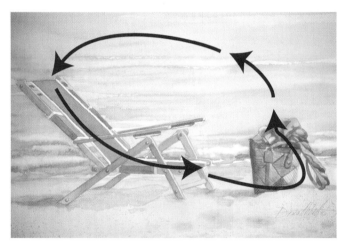

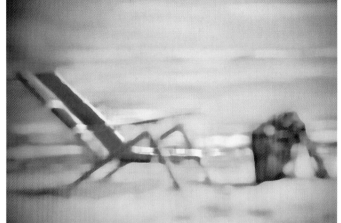

Movement map
Notice how the repeating colors also bring movement to this design. You can see how the intense blues in particular, aided by the lighter blues in the water, guide your eye from point to point in an oval. This is the goal of any artist — to keep the viewer's eye moving around within the painting.

Color map (squint)
The sand and water are virtually the same value, although different colors. This adds to the tranquil mood, and also makes the darker-valued colors stand out.

materials you'll need

paper
140lb (300gsm) cold-pressed watercolor paper

brushes
2" flat
nos. 4, 8 and 12 rounds

other tools
old toothbrush
masking fluid
rubber cement pick-up
2B pencil
facial tissues

your palette for this painting

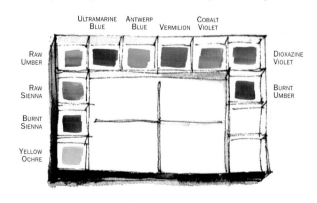

Ask yourself about the following elements

 Light source

The sunlight is coming from the upper right, slightly behind the objects, casting shadows that fall to the left of the objects. The shadows link to form a horizontal line, reinforcing the sense of calm.

 Viewpoint

Getting fairly close up to the objects creates a feeling of intimacy, which is just right for the mood and feeling I was trying to convey.

 Bright idea!

If you're laying down a large expanse of wash and one area dries too quickly, it's best to wait until the whole wash dries, then rewet the area and paint it again. Otherwise, adding water to a nearly dry wash may cause odd-shaped edges.

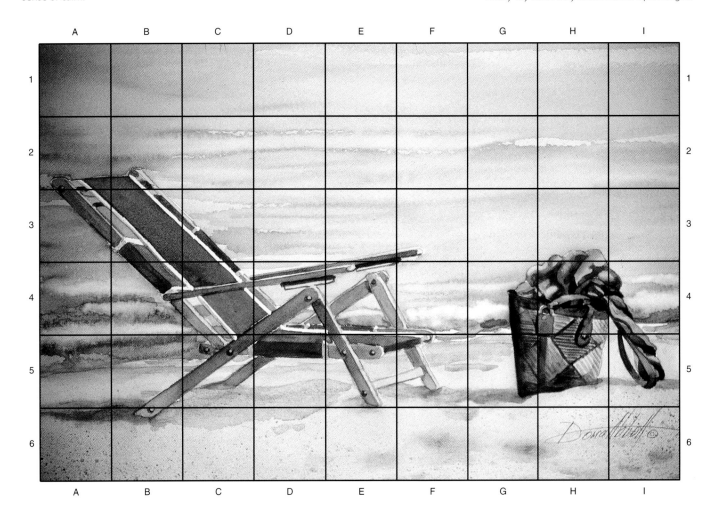

Techniques you'll use

- Preserving whites with masking fluid
- Wet-in-wet washes
- Lifting color
- Wet-on-dry painting
- Dropping in color
- Glazing

 Read me

Very large shapes that are all the same color — such as the sand and the ocean — can look boring if you paint them with just one flat color. Be sure to make some slight color variations as you paint wet-into-wet, and consider adding texture to the pigment as it dries.

 Masking

To preserve the whites use masking fluid to protect white and highlight areas. Use an old or inexpensive small, round brush, apply liquid masking fluid over the entire chair and basket of towels. Let it dry thoroughly before continuing. To make it easier to remove the masking fluid from the brush, when you've finished always rub the brush over a bar of soap first.

Putting it all together

4. Lay in the background

Before starting, mix up a variety of greens — some a little more blue and some more yellow — on your palette. With your wide, flat brush, wet the entire water area thoroughly. Then quickly start laying down the greens in long, horizontal strokes, being sure to vary the color with each stroke. Notice that the water is darker on the left. By waiting to add a few strokes as the paper begins to dry, you'll get those ragged, harder edges that look like waves.

5. Lift some color

Your painting doesn't have to match mine exactly, but you might enjoy adding some cresting waves right near the shoreline. Simply use a small wad of facial tissue to blot up some of the wet pigment.

6. Paint the foreground

Paint the sand area just as you did the water, painting wet-into-wet and varying the sand color from ochre to pinky-beige. Let the colors get a little darker where the sand meets the water to create depth. As the pigment is drying, use a brush to drop in and an old toothbrush to spatter in some light greens and blues. Not only does this create an uneven surface and texture in the sand, it also harmonizes the color scheme.

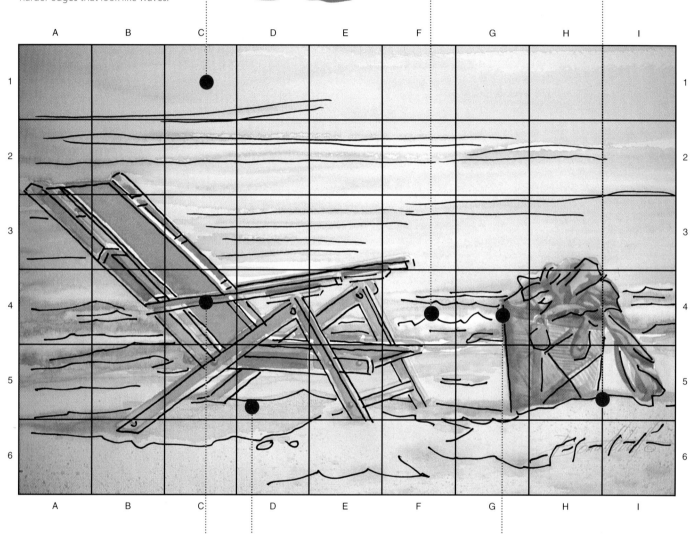

7. Put in the main object

When the foreground and background have dried completely, use the rubber cement pick-up to lift off the masking fluid. Use your smaller brushes and a variety of ochres, siennas and umbers to paint the wood. Keep in mind that the values are lightest on the right where the sun is hitting the chair and they are darker as you move left, away from the sun. The same holds true as you apply sparkling Ultramarine Blue to the seat, carefully painting around the white stripes.

8. Add the cast shadows

In the last step, you'll use blue again to unify the color. Working wet-on-dry, add a glaze of blue to cast a shadow behind the basket and below and behind the chair.

9. Work with textures

As you put in the Antwerp Blue, Dioxazine Purple and Vermilion towels, remember to work from light to dark and shift values to create shadows. Do the same for the Raw Sienna base on the basket. When these colors have dried, use your finest round brush and a dark mixture of Burnt Umber and Ultramarine Blue to add the woven detail. Glaze as needed to adjust colors and values.

Color learning point

Bright colors, such as the vivid blue of the beach chair and the intense hues of the towels, give a painting a lot of impact. They're guaranteed to attract a viewer's eye. But it's possible to have too much of a good thing. A painting cannot be all bright. You have to balance the intense tones with a few softer colors — in this case, the sand and water colors. This is an important concept to remember when creating your own paintings.

Another point to learn from this painting is how to create color harmony. As you can see from the color map (on page 8), or by squinting at the painting itself, I've repeated many of the same colors throughout the painting. The close-up details below reveal how the blue on the chair is echoed in a few spots in the towel and reflected onto the sand beneath the chair. I also mixed the same blues into the greens of the water, and dropped in some of these same greens into the sand. I even added some of the sand color to the waves. This visually ties the foreground to the background and brings about unity and color harmony.

Detail

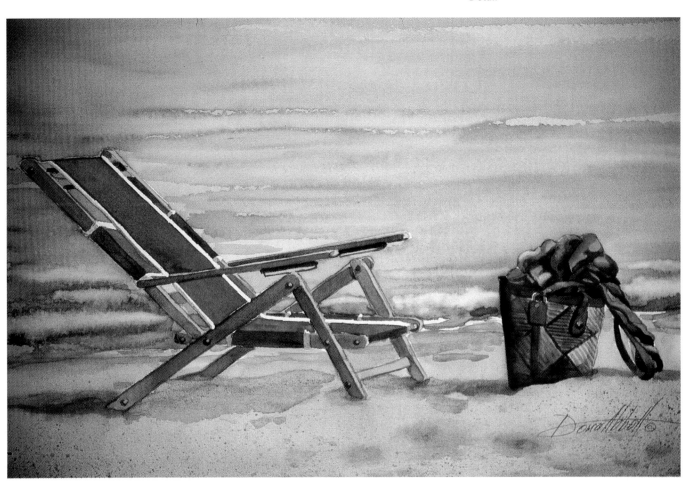

Beach Still Life, watercolor, 10 x 17" (26 x 44cm) by Dona Abbott ©

Detail

Detail

Detail

art map 2

Working with complementary colors

Before you begin, read the entire project through so you know what's going to happen next.

Near where I live, there is a lake that is home to a sizeable population of exquisite Canada geese. Their graceful flight mesmerizes me. Wanting to create a painting that was hushed and yet dramatic, I imagined this twilight scene with the geese coming in for the last landing of the day. I chose a complementary color scheme of dulled orange and blue to support my concept.

When I paint a scene like this, I literally feel the cool evening breeze, hear the sound of the honking geese and smell the moisture in the evening air and the rich fragrance of the lake. By allowing my senses to key in on the sensations of the moment I want to capture, I ensure my own success. You can find success with this method, too, by immersing yourself in the mood of this subject before you begin.

In the future, when you're creating your own works, follow the same approach. As you paint, remember the full experience of seeing your subject for the first time, and look for ways to visually present those sensations within the painting through color and other elements.

1. The image to be transferred using the art map

Read the instructions to see how to map this image across to your paper.

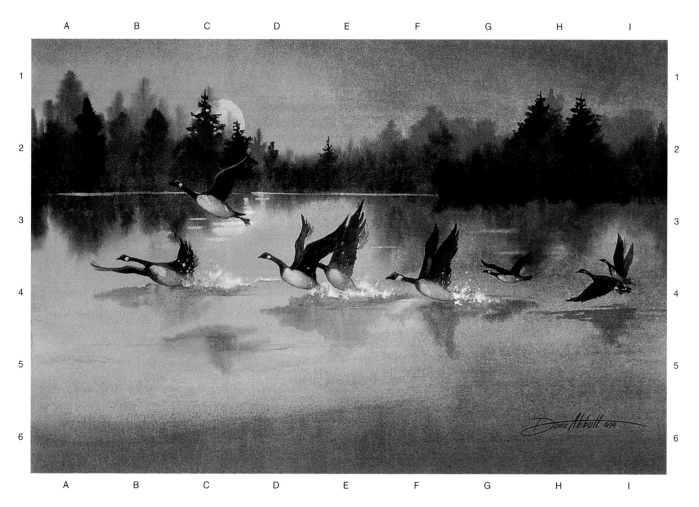

2. Map the image

With a 2B pencil, begin by LIGHTLY drawing a grid on your paper that has the exact same number of squares as my grid. Your paper can be the size of my original, or you can choose something proportionally larger or smaller. Here, your art map will have 6 squares down and 9 squares across. Put in the letters and numbers along the edges to make the next step easier.

3. Use the art map to transfer the image

Now, still drawing very LIGHTLY with your pencil, copy the main contour lines of the objects as shown in each square onto your watercolor paper. It's not necessary to get every detail — just a simple line drawing will do. I recommend LIGHTLY and gently erasing the grid lines in the open, lighter areas before continuing.

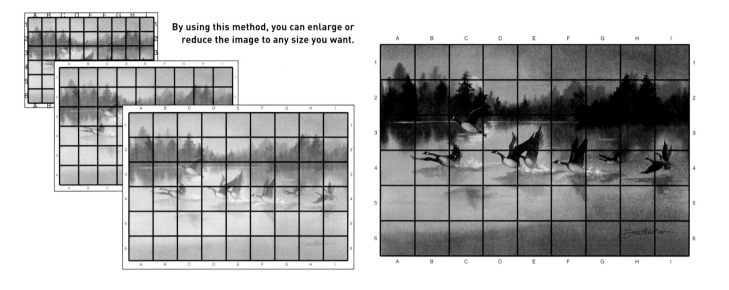

By using this method, you can enlarge or reduce the image to any size you want.

This is how your art map should look.

Here I've done the drawing quite heavily so you can see the idea, but you will do this lightly in pencil.

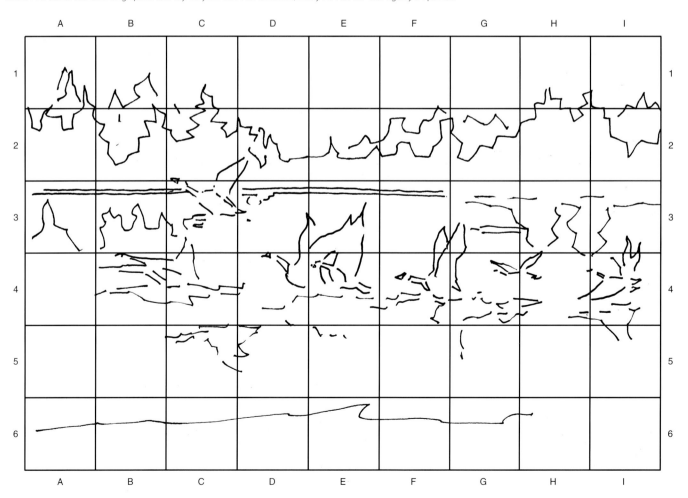

Study these pages before you start painting

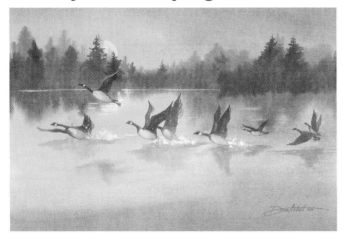

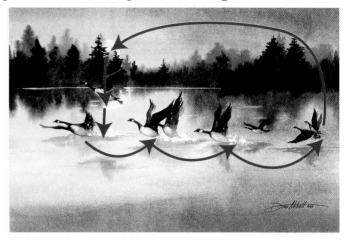

Value and color map
The darkest color and darkest tonal values are spread out in horizontal bands toward the center. The uppermost band in the sky and lowest band in the water are also dark, but not as dark as the trees and geese, which form a frame that keeps the eye moving around the painting.

Movement map
Here, you can see how I used tonal values to create rhythmic movement. The eye jumps from light value to light value, moving in an oval. Similarly, the eye can jump from dark to dark in a pattern that echoes the light values. Together, they hold the viewer's attention around the center of the painting.

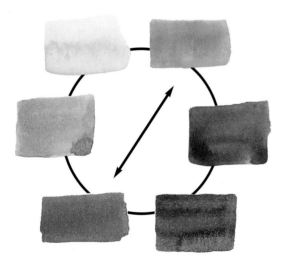

Detail Detail

Color guide
I chose a complementary color scheme. Complementary colors are any two colors that sit across from each other on the color wheel. When used together, two complements tend to visually "vibrate," which creates a sense of drama in a painting. In this case, I chose orange and blue for their eye-catching effect, but I used dulled down versions of them to keep the mood quiet.

Achieving soft gradations of color
When I'm working with large, wet-into-wet washes and I want gentle transitions between colors, I've found it's best to hold my backing board at a 45-degree angle. This allows gravity to pull on the pigment and make it flow down the paper. When the pigment is just about where I want it, I lay the board and paper flat to dry.

materials you'll need

paper
300lb (638gsm) cold-pressed watercolor paper clipped to a backing board

brushes
2" or 3" flat
nos. 4, 8, 12 and 20 round brushes

other tools
old toothbrush
liquid masking fluid
2B pencil
facial tissues
spool of thread
rubber band

your palette for this painting

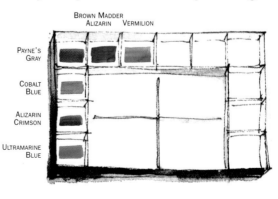

BROWN MADDER
ALIZARIN VERMILION

PAYNE'S GRAY

COBALT BLUE

ALIZARIN CRIMSON

ULTRAMARINE BLUE

Ask yourself about the following elements

Light source

The moon rising above the horizon indicates that the sun has just set behind the viewer. Such low light requires generally darker values.

Viewpoint

By choosing a vantage point floating above the lake, I could look down on the beautiful surface of the water, which is especially interesting where it's broken by the landing geese.

Bright idea!

Here's a great tool for lifting out round objects from wet pigment. Before you begin, assemble the spool of thread, facial tissues and rubber band as shown in this diagram.

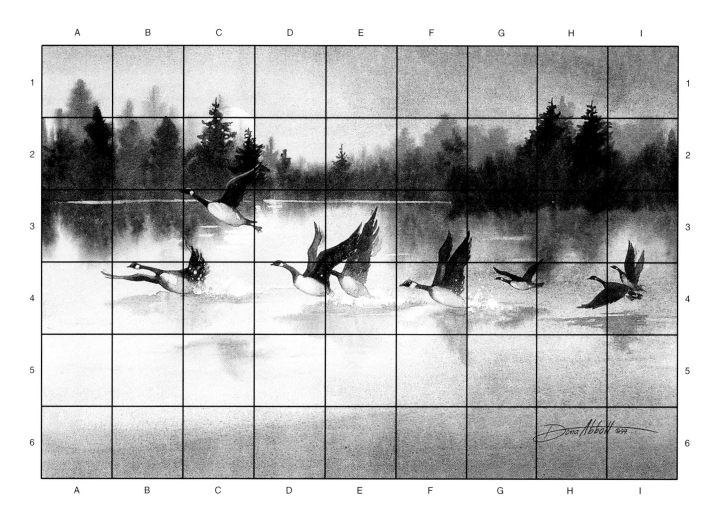

Techniques you'll use

• Preserving whites with masking fluid
• Large, gradated wet-into-wet washes
• Lifting color with a variety of methods
• Wet-into-wet painting
• Wet-on-dry painting

Read me

Large washes such as this painting requires can severely buckle your watercolor paper. This can be minimized by using 300lb (638 gsm) paper, but you can also use 140lb (300 gsm) paper that has been stretched well. To stretch, soak paper for about 15 minutes in cool water, then tape it down to a sturdy backing board with wide packaging tape.

Masking

To preserve the whites use masking fluid to protect white and highlight areas. On the water's surface, just below the four geese that are touching down, use an old toothbrush to spatter masking fluid. Allow to dry before continuing.

Putting it all together

4. Create a gradated wash

You're going to paint the entire surface in one huge, swift wash so first mix up a large quantity of both dull orange and dull blue. Use your largest flat brush to wet the entire surface with a lot of clean water. Using that same wide flat, start to lay in the blues and oranges as shown, working very quickly so you don't have any hard edges. If the big wash dries completely in any area, wait until the wash has dried, then rewet the area and begin again.

5. Lift some color

While the initial wash is still damp, use your thread-spool tool to lift out the moon, then use a wad of clean tissue to lift off some of the pigment in the water, especially in the areas where the geese will be. If you're unhappy with the depth of color in some areas, thoroughly dry the painting with a hair dryer and lay down another wash over the entire surface. Just remember to keep the colors lighter and grayer around the horizon and more intense along the top and bottom edges. This creates the illusion of depth in a landscape.

6. Silhouette the trees

Rewet the paper above the horizon line and lay in slightly darker values of blues and oranges to suggest trees. This initial layer will have a soft edge, suggesting trees in the distance. As the paper becomes more dry, you can add darker layers of trees that will have harder, more distinct edges, indicating trees closer to the shoreline.

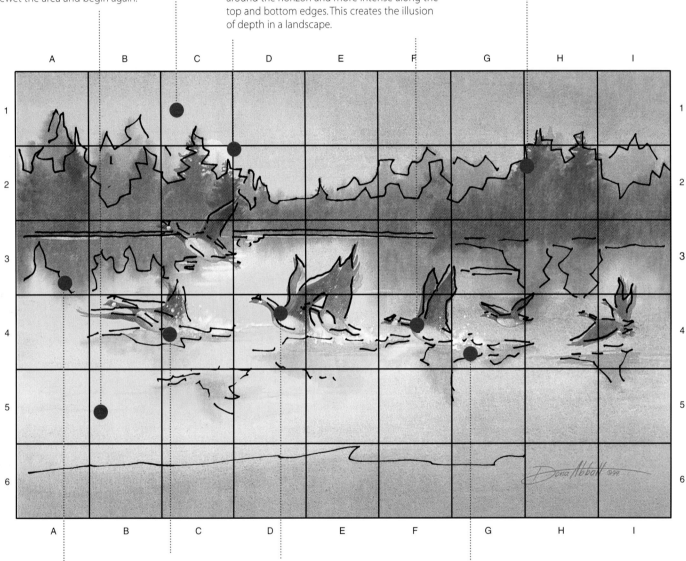

7. Add the reflections

Rewet a large swath below the trees with clean water. Then, using a medium-size round brush, lay down horizontal strokes of darker blues and oranges, following a rough mirror-image of the trees themselves. The strokes will spread to suggest soft-edged reflections over gently rippling water. While the paper is still wet, use a slightly damp, "thirsty" brush to lift off a light line along the shoreline. Use the same method to paint the general shapes of the reflections below the geese.

8. Paint the geese

Using a fine brush and dark tones mixed with blues for color harmony, paint in the forms of the geese. Use a "thirsty" brush to lift some pigment and create a three-dimensional effect. The white areas of their bodies should have some touches of orange and blue reflected color.

9. Finish with the splashes

Finally, when the painting is completely dry, lift off the masking fluid with a rubber cement pick-up. Lay a light glaze over some of the whites to soften the edges and add natural variations in the tones.

Color learning point

I liked the dramatic look of the blue against the orange, but I wanted the overall effect to be somewhat subdued. To diminish the intensity of my orange, I added a little blue. To tone down the blue, I added a little orange. Adding a color's complement will always neutralize, or dull down, the original color, as you can see by comparing these pure colors against the painting.

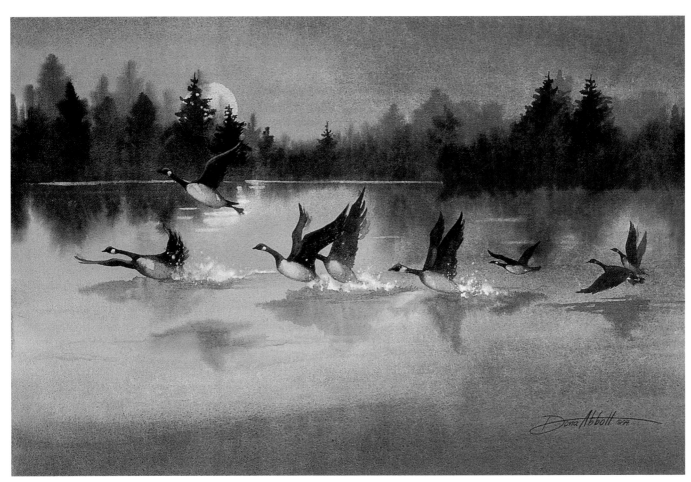

Night Flight, watercolor, 21 x 29" (54 x 74cm) by Dona Abbott ©

Detail Detail Detail

art map 3
Offsetting pure colors with mixed neutrals

Glacier National Park in Montana is one of America's protected wild spaces. The air is so clear and the sky so vast that Montana is known as "Big Sky Country." The elk, with his antlers in velvet, not only belongs in this pure environment but is master of all he surveys.

I aimed to convey both the pristine majesty of the mountains and the regal quality of the proud elk with this painting. That's why it was important to depict the unique characteristics of this particular setting and this particular elk, rather than simply paint generic versions of my subject. This glacier is unique in the way it had eroded, in its fault lines, in its shape and colors. The elk's antlers had a distinct look and texture to them, as well.

When you're painting your own works, you can strengthen their impact on the viewer by remaining faithful to the unique characteristics of your subjects.

Before you begin, read the entire project through so you know what's going to happen next.

1. The image to be transferred using the art map

Read the instructions to see how to map this image across to your paper.

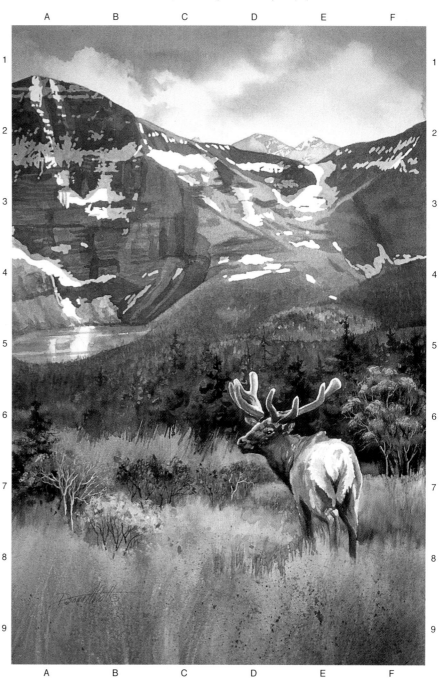

2. Mapping the image

With a 2B pencil, begin by LIGHTLY drawing a grid on your paper that has the exact same number of squares as my grid. Your paper can be the size of my original, or you can choose something proportionally larger or smaller. I wouldn't go too small, however, or the elk will be a tiny dot within the landscape. Your art map will be 6 squares down and 9 squares across. Put in the letters and numbers along the edges to make the next step easier.

3. Use the art map to transfer the image

Now, still drawing very LIGHTLY with your pencil, copy the main contour lines of the objects as shown in each square onto your watercolor paper. It's not necessary to get every detail — just a simple line drawing will do. I recommend LIGHTLY and gently erasing the grid lines in the open, lighter areas before continuing.

By using this method, you can enlarge or reduce the image to any size you want.

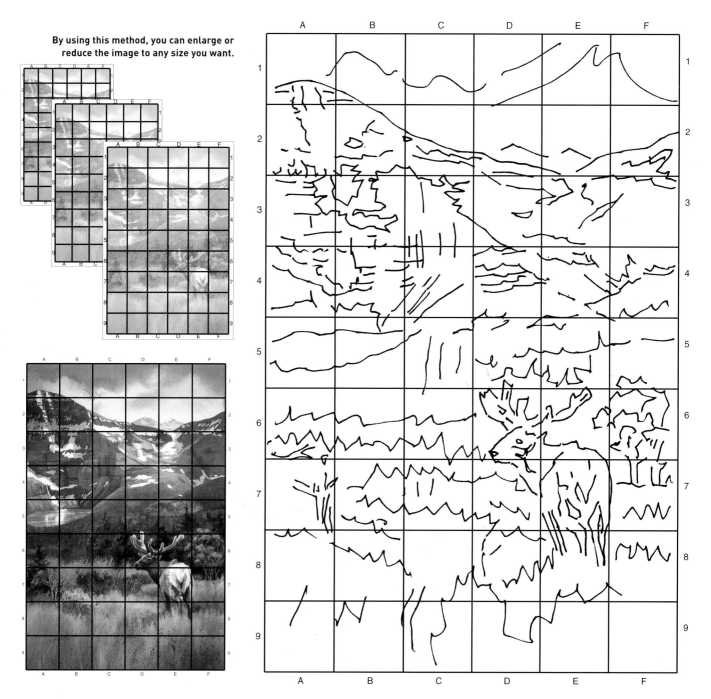

This is how your art map should look.

Here I've done the drawing quite heavily so you can see the idea, but you will do this lightly in pencil.

Study these page before you start painting

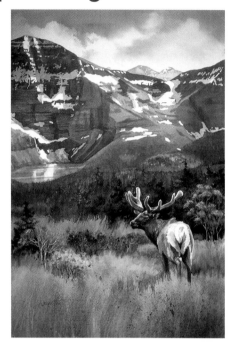

Focal point guide

Most paintings have at least one focal point, sometimes more. The main focal point should be the most important element or feature in the painting, while the secondary focal points provide additional notes of interest for the viewer. You will usually attract your viewer's eye to a focal point by using some type of contrast, such as extreme value contrast, a bright color against a neutral, a sharp edge surrounded by softer edges and so on.

Positioning the focal point is also important. An easy way to position your focal point in a pleasing location is to imagine a tic-tac-toe grid overlaying your image. Any of the four intersections are "sweet spots," or good positions for a focal point. As you can see here, I put the elk (identified as a focal point because of the extreme value contrasts) in the lower right intersection. The highest contrast of white snow against dark mountain, as well as the sharpest edges, also fall near a sweet spot.

Design and shape map

The vertical format is roughly divided into four sections. But notice how the sizes and shapes of each section differ. In this case, the massive glacier shape is balanced by the strong figure of the elk. It's important to have a variety of shapes in any composition.

Tonal value map

When you squint at this painting, you'll see the lightest values standing out. Notice how they link up, connecting the focal points and guiding the eye around the painting.

 Bright idea!

There's no reason a watercolorist can't use brushes designed for other media. Here, you'll use a fan brush. Experiment with other types of brushes, such as bristle brushes, to see what effects you can get.

materials you'll need

paper
140lb (300 gsm) cold-pressed watercolor paper

brushes
1" and 2" flats

nos. 4, 8 and 12 rounds

grass comb (a special brush with separated hairs)

fan brush

other tools
2B pencil

spritzer bottle filled with water

natural sponge

masking fluid

rubber cement pick-up

old toothbrush

facial tissues

your palette for this painting

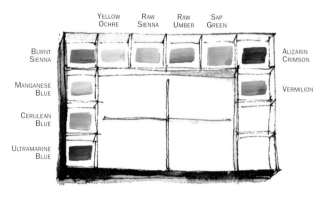

Ask yourself about the following elements

Light source

The midday sun was high overhead, so the light is coming almost directly from above and slightly to the right. Keep this in mind when putting in the shadows.

Viewpoint

Notice how the elk faces into the center of the painting, helping to keep the viewer's eye circling around the interior.

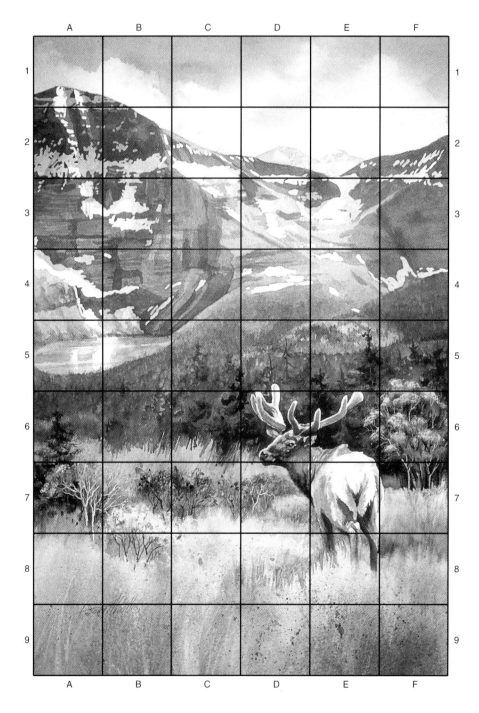

Techniques you'll use

• Preserving whites with masking fluid
• Wet-into-wet painting
• Wet-on-dry painting
• Glazing

Read me

Since the glacier, tree line and elk are so complex, it's good to have a simple sky and foreground. Don't overdo your textures in these two secondary areas.

Masking

To preserve the whites use masking fluid to protect white and highlight areas. With an old or inexpensive brush, mask off the elk and the white patches of snow. Let it dry thoroughly before continuing.

Putting it all together

5. Simplify the sky

To paint the sky, wet the entire area with clean water, then lay in some blues, painting around areas to create clouds as shown. While the sky is still wet, soften the cloud edges by blotting with a crumpled facial tissue.

6. Paint the glacier blues

Using the three blues, apply strong washes to the rocky parts of the mountain, allowing colors to blend on the paper. Glaze over with darker shades to create striations, crevices and shadows. Remember that the masking fluid is still protecting the white snow areas.

7. Mix dull greens for the trees

Combine Sap Green with some of the earth tones for lighter areas and with the blues for shadowed areas. Then apply wet-into-wet in the trees, occasionally spritzing with clean water to encourage the pigment to move in irregular ways. As the pigment dries, add more detail and shadows.

8. Fan the foreground

Initially, paint the foreground with a wet-into-wet wash of Raw Sienna, moving into Yellow Ochre toward the lower edge of the paper. As you layer on more color, use a fan brush or grass comb in upward strokes to suggest long blades of grass. Create the texture of the low bushes by applying paint with a natural sponge. Some of these layers or strokes should have touches of blue mixed in for color harmony. You can also sprinkle a little clean water or use a toothbrush to spatter drops of other colors over the grass to create more texture.

9. Modify the snow

To complete the painting, glaze over some shadowed portions of the snow with pale tints of blues and blue-grays. Remember that cooler tones recede while warmer tones come forward.

10. Paint the elk

After removing all of the masking with a rubber cement pick-up, paint the elk with small round brushes. The earth colors are perfect for his face and chest, and some blues can be added to model the form of his white body. Be sure to leave the uppermost parts of his antlers white or nearly white to show the sunlight hitting this velvety surface.

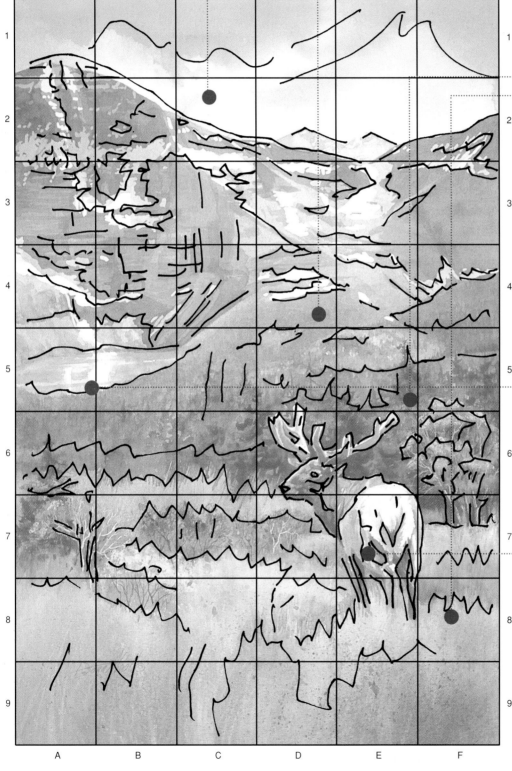

Color learning point

As we saw in the first Art Map project, *Beach Still Life*, it's important to offset brights with neutrals. Here, with the goal of depicting the chilly quality of this glacier in mind, I knew I would have to use pure hues of a variety of blues to create the icy cold look. This prompted me to balance them with warm mixes of dull, dark greens and earth colors. The contrast of the two intensifies the brighter colors, helping the painting communicate a unique moment in time.

And once again, I repeated colors to harmonize the painting. Look closely and you'll see flecks of blue in the foreground grasses and the shaded sides of the elk, as well as hints of earth tones in parts of the glacier.

Detail

Detail

Detail

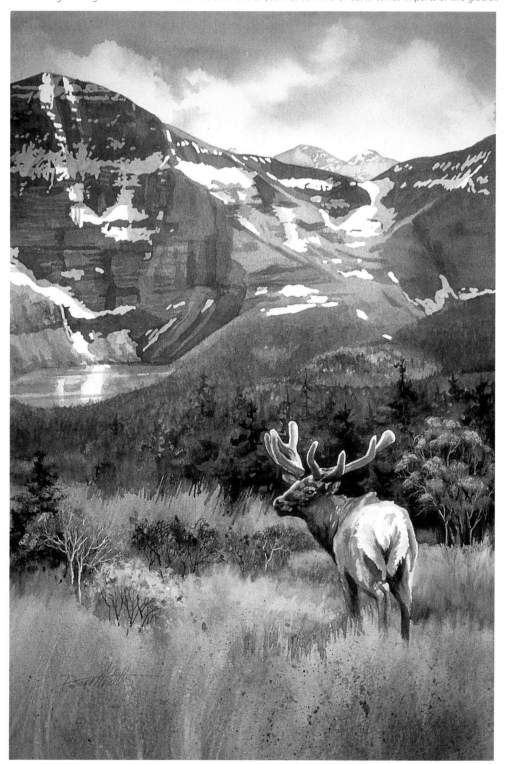

Glacier's Guardian, watercolor, 27 x 20" (69 x 51cm) by Dona Abbott ©

Detail

art map 4

Learning about color temperature

Before you begin, read the entire project through so you know what's going to happen next.

Each spring in our town, the gardens of an iris farm draw visitors like a magnet. What an astonishing array of varieties and colors! I was commissioned to do a painting of irises, using predominantly pink and purple tones. The rest was left up to me.

Inspired by the jumbled look of the garden itself, I decided to make a painting about color and pattern. Unlike the previous painting, which has clear focal points, this painting has no single focal point. Instead,

I wove the tonal values of the blooms and greenery into a pattern that moves the eye from place to place. I started by drawing some blossoms in a rhythmic design, varying their size and placement. The foliage was intentionally sublimated, allowing the focus to be on the blossoms.

Variation is the key to success in this painting — variation in size, shape, color, angle and value. This concept is essential to good painting. Variation is what prevents

a painting from becoming boring. It adds interest and a sense of real life to the work.

For example, notice how the blooms run the gamut from tight buds to full blooms to withered, aging flowers. Another type of variation you'll want to pay particular attention to is color temperature. Look at how the greens range from warm yellow-green to cool blue-green. This is going to be a great exercise in learning to mix color according to temperature.

1. The image to be transferred using the art map

Read the instructions to see how to map this image across to your paper.

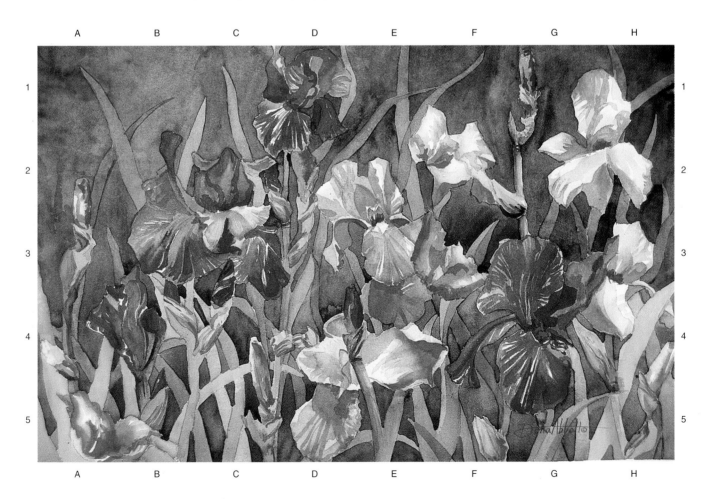

2. Mapping the image

With a 2B pencil, begin by LIGHTLY drawing a grid on your paper that has the exact same number of squares as my grid. Your paper can be the size of my original, or you can choose something proportionally larger or smaller. Here the art map has 5 squares down and 8 squares across. Put in the letters and numbers along the edges to make the next step easier.

3. Use the art map to transfer the image

Now, still drawing very LIGHTLY with your pencil, copy the main contour lines of the objects as shown in each square onto your watercolor paper. It's not necessary to get every detail — just a simple line drawing will do. I recommend LIGHTLY and gently erasing the grid lines in the open, lighter areas before continuing.

By using this method, you can enlarge or reduce the image to any size you want.

This is how your art map should look.

Here I've done the drawing quite heavily so you can see the idea, but you will do this lightly in pencil.

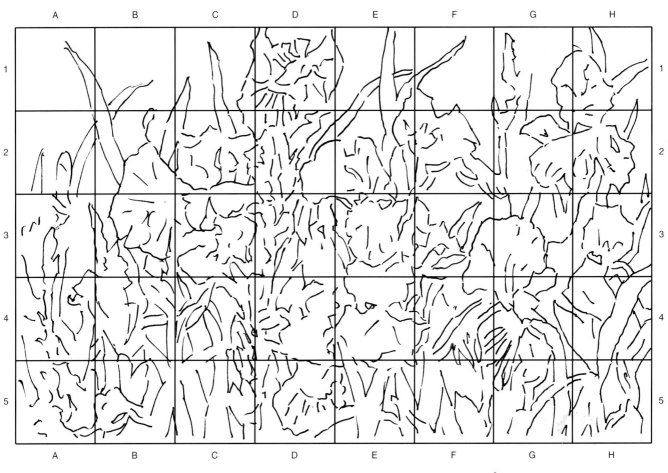

Study these pages before you start painting

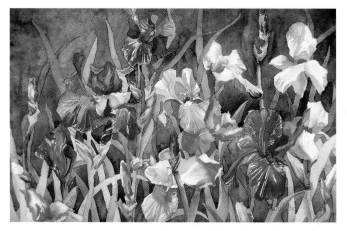

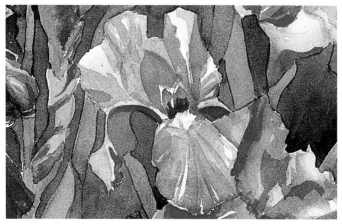

Tonal value map
Notice how the lighter values create a path for the viewer's eye to follow to different parts of the painting. The human eye is generally drawn to the lightest value and highest contrast first, then "reads" progressively darker values and diminishing contrast.

Detail

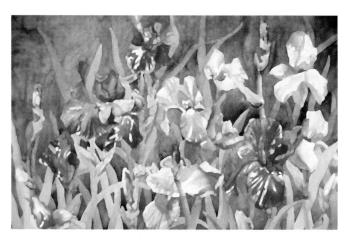

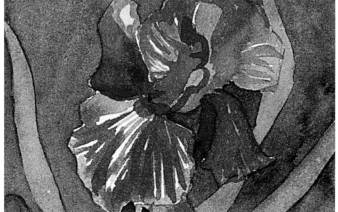

Color map
A fairly even distribution of pink and purple flowers also keeps your eye moving from place to place.

Saving the whites
This time paint around the whites instead of using masking fluid. Masking fluid is a wonderful way to save the white areas of your image, but it's not always necessary. Sometimes you may want to carefully paint around white areas with the brush, as I did for this picture. With this method, you have more control over the edges of the white spaces.

materials you'll need

paper
140lb (300 gsm) cold-pressed watercolor paper

brushes
2" flat
nos. 8 and 12 round
¾" oval wash

other tools
2B pencil
spritzer bottle filled with water

your palette for this painting

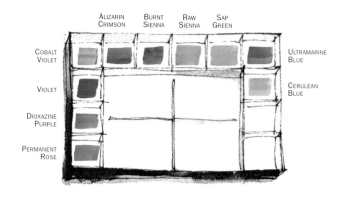

ALIZARIN CRIMSON BURNT SIENNA RAW SIENNA SAP GREEN

COBALT VIOLET ULTRAMARINE BLUE

VIOLET CERULEAN BLUE

DIOXAZINE PURPLE

PERMANENT ROSE

Ask yourself about the following elements

 Light source

Here, the sunlight is overhead and slightly to the left. The petals and leaves facing that direction are lightest in value. The shadows will fall below and to the right.

 Viewpoint

A frontal view allowed me to take advantage of the wonderful shapes of the individual flowers, as well as the exciting overall pattern of the foliage.

 Bright idea!

A large wash of a single color can look dull. To create a little soft texture in a still-wet wash, spritz it with clean water from a misting spray bottle or use a brush to flick clean water over the surface.

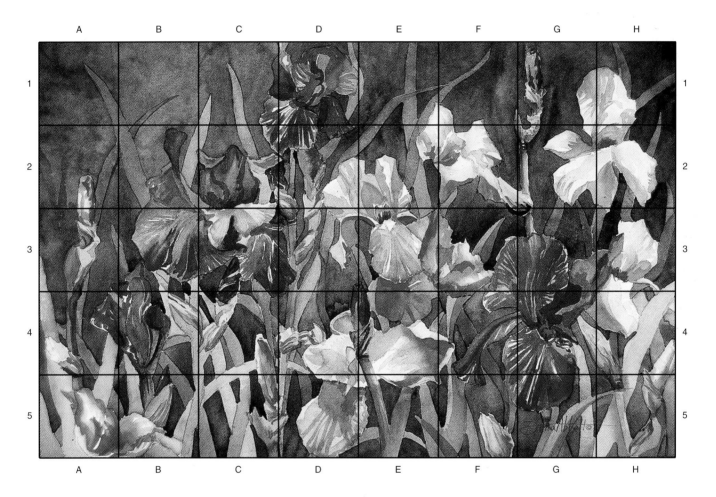

Techniques you'll use

- Wet-on-dry painting
- Wet-into-wet painting
- Painting freehand around the whites

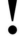 **Read me**

It's easy to get carried away and forget to paint around the white spaces. But this is one of those mistakes that's easy to correct. Simply keep a small, slightly damp round brush on hand. Pinch the hairs to make a fine edge. Then run this "thirsty" brush over the wet pigment wherever you want the white space. The semi-dry brush will absorb and lift back the pigment, creating a soft-edged white area.

Putting it all together

4. Preserve the whites

Study the color map on the previous page before you begin so you have a good sense of which flowers are predominantly pink and which are predominantly purple. Notice how there's an even distribution of both. Now lay down a pale wash of the appropriate colors on each bloom and bud, carefully working around white spots. If you cover an area you meant to keep white, use a thirsty brush to lift back some wet pigment.

5. Enhance the blooms

Next, carefully observe the large reproduction of the painting on the next page and glaze over parts of the flowers to suggest three-dimensional form and shadows. Note that the purple flowers have touches of pink and vice versa. Paint small areas wet-into-wet where you want to have soft transitions, but paint wet-on-dry to create hard, distinct edges. Most of all, remember your color temperatures — see what you can do to make your pinks and purples slightly warmer and cooler by adding other palette colors, then place them accordingly.

6. Add the leaves

Another opportunity to mix colors on your palette! It's time to turn that one tube green — Sap Green — into a host of beautiful variations. Try adding any of the other palette colors to see if Sap Green gets warmer (more yellow) or cooler (more blue). Use the warmer greens you create in the foreground leaves, and be sure to vary their values, too. Let all of the leaves and flowers dry completely before continuing.

7. Start the lower background

Finally, mix up large quantities of several cool, harmonious greens by combining Sap Green with darker hues, such as Dioxazine Purple or Violet and Burnt Sienna. Then use a small round brush to fill in the remaining white spaces along the bottom, between the leaves and flowers. It's okay if the green overlaps some of the other objects — it will just add more tonal variations.

8. Finish the background

When you're ready to paint the large portion of background at the top, add a little more water to the dark green mixes to lighten their values. But you don't want this to be an even solid. Continue to work in some variations in color, value and texture. Use a ¾" oval brush to apply the paint. While it's still wet, spritz or flick some clean water over these passages to move the pigment and create a more mottled, uneven effect. Gently mop up any excess water with a tissue when you're finished.

Color temperature — an explanation

Understanding color temperature is very important because it's the best means of creating the illusion of depth in any painting. Cool colors recede while warm colors advance, which is why these cool greens stay in the background where they belong and the warmer greens appear to be closer to us. It also explains why the petals and flowers look three-dimensional. You can always rely on this principle to make elements or even parts of objects come toward the viewer or move back in space.

Color temperature may sound like a difficult concept, but it's easier than you think. Every tube color — be it yellow, orange or blue — is either warm (having yellow overtones) or cool (having blue overtones). Additionally, you can add other colors to a color to "push" it more toward warm or cool. This is where understanding your palette colors and learning to mix them gets really fun!

As always, repeated colors help to unify the painting and tie background to foreground.

Detail

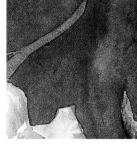
Detail

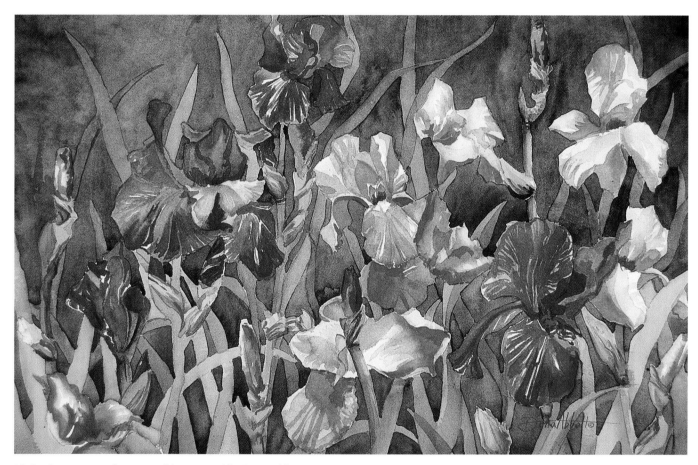

Iris Study #1, watercolor, 15 x 23" (38 x 59cm) by Dona Abbott ©

Warm colors

| Cadmium Yellow | Cadmium Red | Sap Green | Cerulean Blue |

Cool colors

| Lemon Yellow | Alizarin Crimson | Viridian | Ultramarine Blue |

art map 5

Harmonizing color

Before you begin, read the entire project through so you know what's going to happen next.

As I emerged from the elevator of Washington, DC's metro, my eyes fell on an incredible scene — bouquet after bouquet of all different types of colorful flowers. I was suddenly enveloped in their mingled fragrance and the joy of the stunning blooms.

Back in my studio, I sought to recreate the scene from the few photos I had been able to snap. The original photos required editing — quite a bit of it — to whip them into a respectable composition. I needed to consider carefully where to place the different colors of flowers in order to organize and balance out the composition while simultaneously creating harmony.

If this painting looks too detailed for your skill level, don't be intimidated. Look closely and you'll see that most of these flowers are only suggested. I'm going to teach you how to create this illusion — it will be easier than you think.

1. The image to be transferred using the art map

Read the instructions to see how to map this image across to your paper.

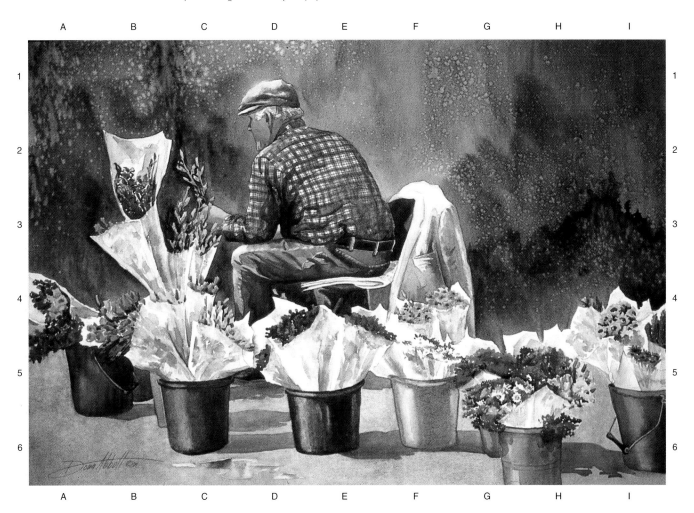

2. Mapping the image

With a 2B pencil, begin by LIGHTLY drawing a grid on your paper that has the exact same number of squares as my grid. Your paper can be the size of my original, or you can choose something proportionally larger or smaller. Here the art map will be 6 squares down and 9 squares across. Put in the letters and numbers along the edges to make the next step easier.

3. Use the art map to transfer the image

Now, still drawing very LIGHTLY with your pencil, copy the main contour lines of the objects as shown in each square onto your watercolor paper. It's not necessary to get every detail — just a simple line drawing will do. I recommend LIGHTLY and gently erasing the grid lines in the open, lighter areas before continuing.

By using this method, you can enlarge or reduce the image to any size you want.

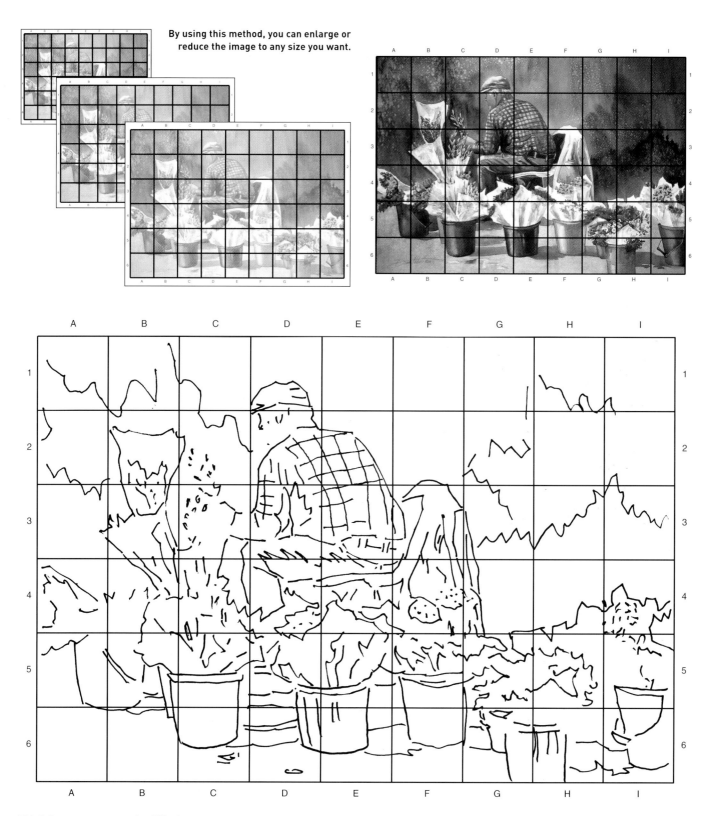

This is how your art map should look.

Here I've done the drawing quite heavily so you can see the idea, but you will do this lightly in pencil.

Study these pages before you start painting

Design map
Placing the figure to the left of center and facing out of the painting makes the composition slightly off balance. It adds a nice touch of activity and just a little bit of tension. The figure is balanced by the cluster of bouquets that echo the color of his shirt.

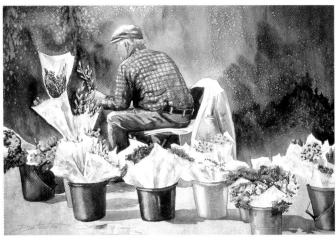

Tonal value map
The dark value of the background makes it recede and also creates a nice backdrop, setting off the alternating values of the buckets of flowers. Conversely, the light value of the foreground makes it come forward.

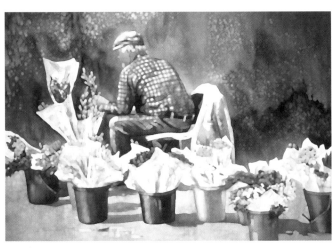

Color map (squint)
From this, you can see how the neutral-colored background makes the bright flower colors look even brighter. You can also see how the flower colors are carefully balanced throughout the image.

Edge guide
As objects move back into the distance, their edges appear softer or more blurry. That's why I used softer edges in the background and on the figure, and crisper edges on the buckets and plastic flower wrap.

materials you'll need

paper
140lb (300 gsm) cold-pressed watercolor paper

brushes
1" and 2" flats

nos. 4, 8 and 12 rounds

other tools
2B pencil

coarse salt

facial tissues

your palette for this painting

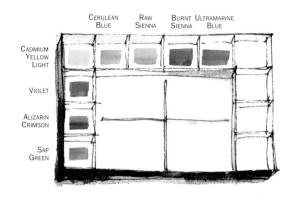

Ask yourself about the following elements

 Light source
Light coming from the upper left casts shadows that fall directly to the right of the objects.

 Viewpoint
By looking slightly downward on the bouquets, I could take advantage of and show off their rich, vibrant colors.

Bright idea!
Sometimes cast shadows can become a valuable asset. Here, I used them to link the buckets together into a flowing shape.

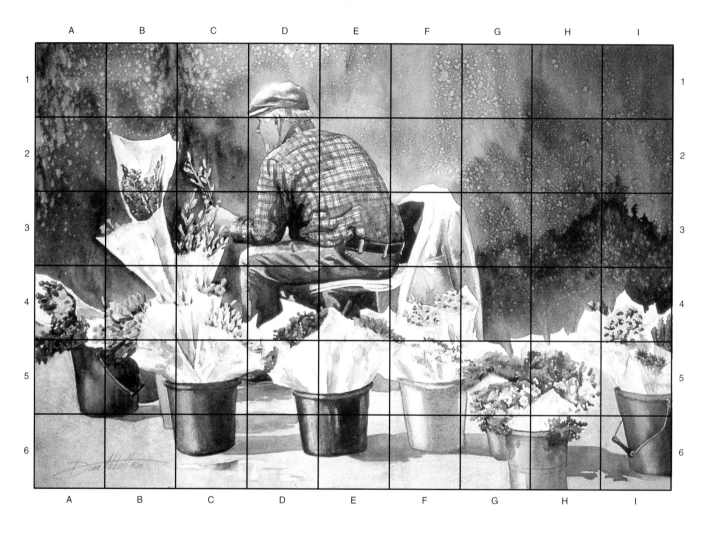

Techniques you'll use

• Putting salt on wet-into-wet washes

• Wet-on-dry painting

• Blotting and lifting

• Glazing

 Read me
There will be many times when too much detail can ruin a painting, so it's important for you to learn how to imply detail without actually going overboard in painting it.

Putting it all together

4. Salt the background

Wet the entire background, working carefully around the figure and the white plastic wrap on the flowers. Be sure to lay in a variety of earth tones, and even include a touch of red or blue. Just as the wash begins to lose its sheen, sprinkle some coarse salt over parts of the background to create texture. Allow to dry thoroughly before removing the salt.

5. Add the figure

It's okay to move on to the figure while the background is still slightly damp because it will help create softer edges. However, make sure there isn't any salt in the figure shape. To paint the checked pattern of the shirt, use a small round brush to put in the red stripes in both directions. After the red has dried, work wet-on-dry to put in the shadows and folds. Together they'll look like fabric. You can use a similar approach with the pants, head and hat, putting in a base color and then layering on the shadows.

6. Put in the foreground

Again, lay a wet-into-wet wash for the foreground, working around the buckets and plastic wrap but painting over the cast shadow areas. Keep this shape simple with only slight color variations. Don't forget to include the little puddle, which helps to balance the composition and provides an opportunity to repeat some blues. Incorporating both light and dark values in the puddle helps create the illusion of water.

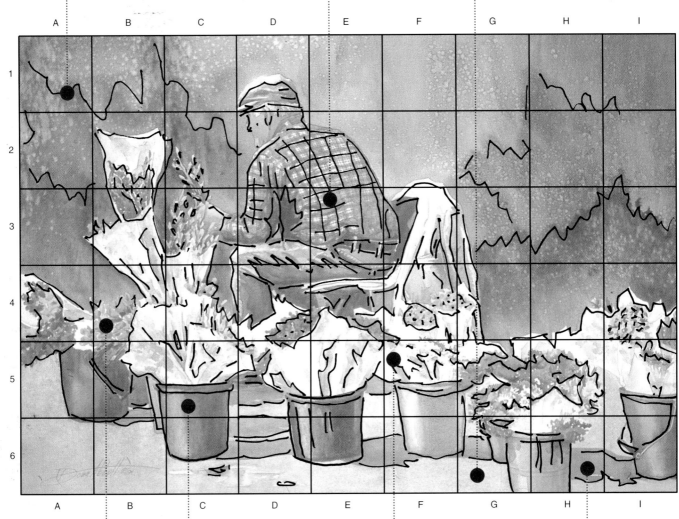

7. Paint the buckets and flowers

The buckets can be painted with a simple wet-on-dry and layered approach, using the colors as shown. Then it's time to have some fun with vibrant color in the flowers. Use your smallest round brushes and a multitude of colors. Don't worry about painting every detail — just suggest the general shapes and a few details to make them believable. Refer to photos of flowers to learn the unique shapes, shadows and colors of different varieties.

8. Create the plastic wrap

The white plastic wrap around the flowers is translucent, allowing some of the flower color beneath to show through. To create this illusion, apply lighter values of the flower colors and blot with a facial tissue to make them even lighter. When that's dry, you can paint wet-on-dry in pale greens and blues to suggest the folds of the wrap itself.

9. Finish with cast shadows

Mix up a medium value of a lively blue-gray, then put in the cast shadows as shown.

Color learning point

I carefully arranged the various colors within the composition to fall into patterns that guide the viewer's eye around the painting. Once again, repeating the colors has helped to unify the image. Even the brown background was repeated in some foreground buckets to tie the two together.

However, notice that I didn't duplicate the exact colors, but rather used a variety of tints (lighter values) and shades (darker values) of the same colors to create color families. Now you can see how the principles of repetition and variation are working together to make the painting more interesting.

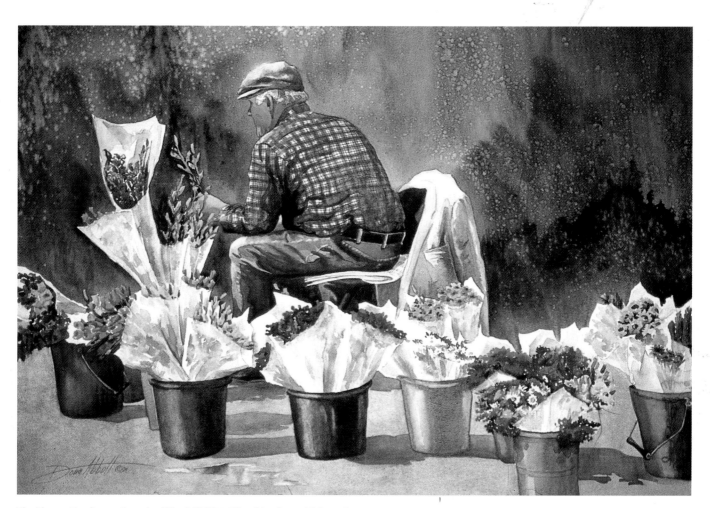

The Flower Vendor, watercolor, 20 x 28" (51 x 71cm) by Dona Abbott ©

Detail

Detail

Detail

art map 6
Mixing bright and dark colors

Before you begin, read the entire project through so you know what's going to happen next.

Anyone who has gone scuba diving or snorkeling can attest to the incomparable color and beauty of the undersea world. Few things in nature are as brilliant and bright as tropical fish. The vivid colors of aquatic life give the artist a chance to use colors in their purest form. What a great subject!

Like the previous Art Map project, this one looks more difficult than it actually is. Have faith in your ability to do this, and you'll be so pleased with the end result! You're going to have fun with this salt background, and I know the practice you'll get with mixing and using these bright and dark colors is going to improve your confidence even more.

1. The image to be transferred using the art map.

Read the instructions to see how to map this image across to your paper.

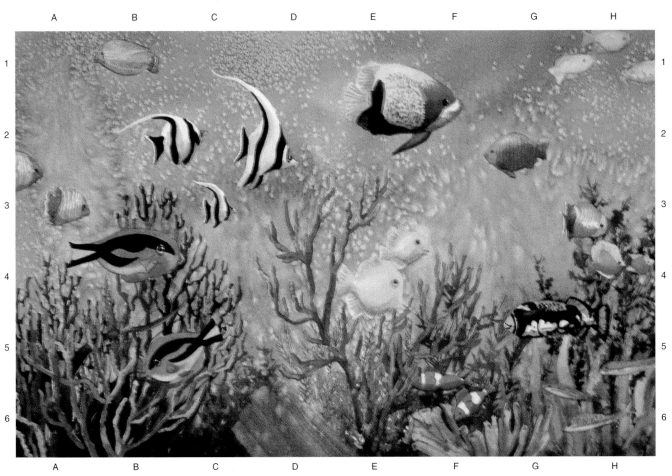

2. Mapping the image

With a 2B pencil, begin by LIGHTLY drawing a grid on your paper that has the exact same number of squares as my grid. Your paper can be the size of my original, or you can choose something proportionally larger or smaller. Your art map will be 6 squares down and 8 squares across. Put in the letters and numbers along the edges to make the next step easier.

3. Use the art map to transfer the image

Now, still drawing very LIGHTLY with your pencil, copy the main contour lines of the objects as shown in each square onto your watercolor paper. It's not necessary to get every detail — just a simple line drawing will do. I recommend LIGHTLY and gently erasing the grid lines in the open, lighter areas before continuing.

By using this method, you can enlarge or reduce the image to any size you want.

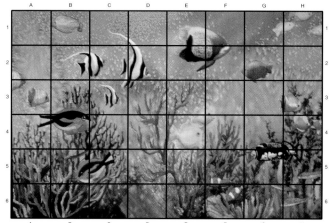

This is how your art map should look.

Here I've done the drawing quite heavily so you can see the idea, but you will do this lightly in pencil.

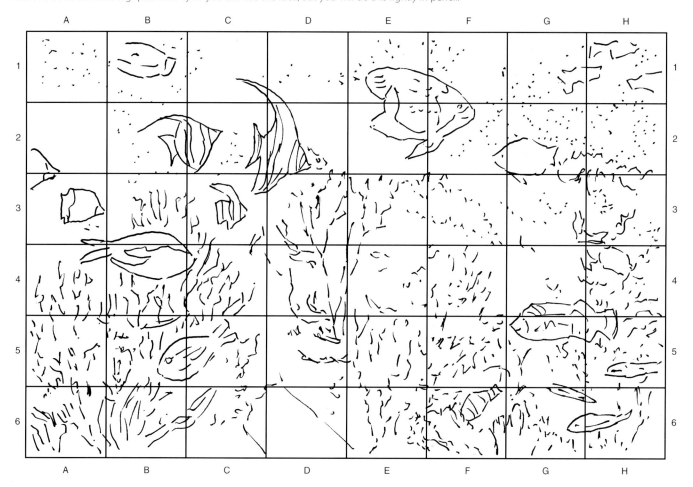

Study these pages before you start painting

Smart composing

Before starting a complex painting, I recommend trying several different layouts to see what is going to be the most effective arrangement. A quick way to do this is to make photocopies of your drawings of the individual elements you plan to use. You can enlarge or reduce them or flop them to reverse their direction. Once you have cut out the pieces, you can lay them on your paper surface in different configurations, experimenting to find the best value pattern, movement and so on. Once you've found the arrangement you like, consider making notations about color so you can distribute the color wisely, as I've done in *Waterworld*.

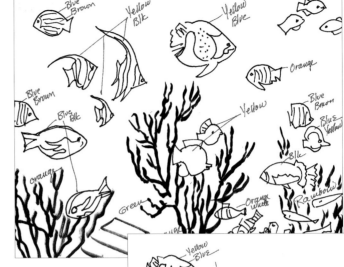

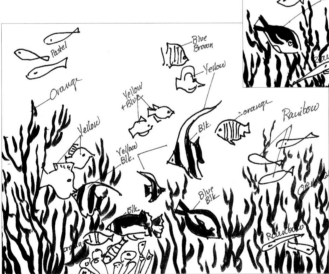

materials you'll need

paper
140lb (300 gsm) cold-pressed watercolor paper

brushes
3" flat

nos 4, 8 and 12 rounds

other tools
2B pencil

water spritzer bottle

coarse salt

masking fluid

rubber cement pick-up

your palette for this painting

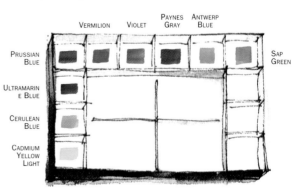

Ask yourself about the following elements

 Light source

Since this is an underwater scene, light filters in from above. Make the top sides of the fish and coral lighter in value with the undersides slightly shadowed.

 Viewpoint

Much like *Iris Study #1* on page 24, a straight-on vantage point allows us to see the unusual shapes and colors of the fish and coral. It makes the viewer feel like part of the scene.

 Bright idea!

When you use salt to create texture, don't just sprinkle it on and let it sit. You can also spritz some of the salt with clean water and tilt your backing board so that gravity pulls the salt and water around, creating even more varied textures.

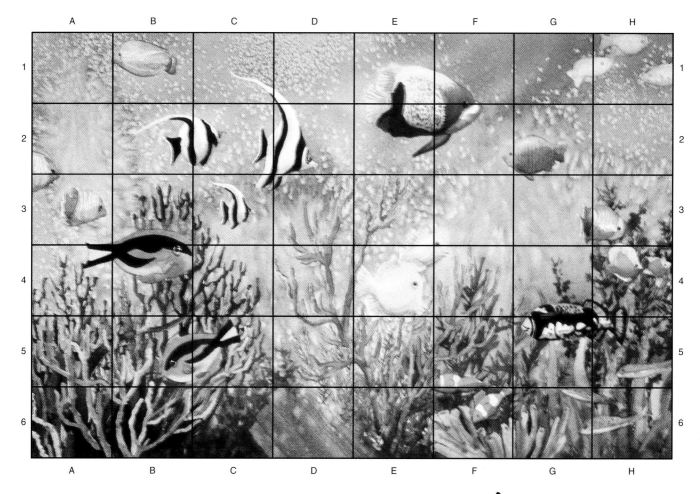

Techniques you'll use

• Preserving whites with masking fluid
• Large, multi-colored wet-into-wet washes
• Using salt to create texture
• Wet-on-dry painting
• Glazing

 Read me

Dark values feel "weighty," so in a predominantly light-value painting like this, place the darks carefully. Keep them toward the bottom to act as a visual anchor.

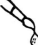 **Masking**

To preserve the whites use masking fluid to protect white and highlight areas. With an old or inexpensive small, round brush, apply liquid masking fluid carefully over all of the fish and the coral. Let it dry thoroughly before continuing.

Putting it all together

4. Create a watery texture

Wet the entire sheet with clean water, then flood in different shades of blue and green over the masking fluid which will protect the fish. Tilt the board to encourage colors to mingle. Just as the sheen begins to fade, sprinkle coarse salt across the surface. In some areas, spritz more clean water over the salt and tilt the board some more. The unpredictable textures suggest moving water.

5. Put in the background coral

While the background is still slightly damp so you create softer edges, paint the background coral with a small, round brush. Use a variety of cooler, dull greens to make them recede into the background. These colors can be darker in value to give weight to the bottom of the painting. Let the painting dry thoroughly before continuing.

6. Start the fish

When you use the rubber cement pick-up to remove the masking from the fish and coral, some of your drawing of the patterns of the fish may lift off and need to be re-drawn. Next, lay down a foundation color on each fish. Follow my color scheme carefully. Add relatively little water to your pure pigments so the colors stay intensely bright.

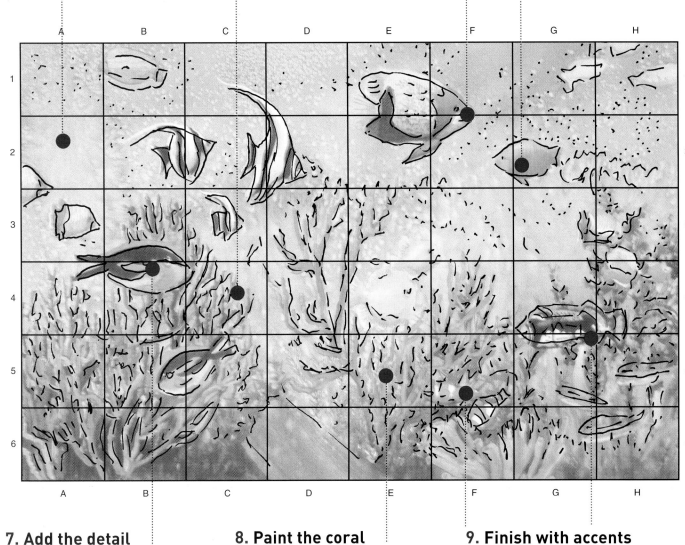

7. Add the detail

Continuing to use bright colors and small, round brushes, go over each fish, adding details and patterns. Remember the light source coming from above and the need for shadows below. To mix that velvety black seen on several of the fish, combine Ultramarine Blue, Alizarin Crimson, Violet and a little Paynes Gray. You can vary the proportions so that all darks are not identical.

8. Paint the coral

Remember to vary the tonal values and color temperatures of your coral colors to make it look three-dimensional, as if it curves and exists in space.

9. Finish with accents

Before you call the painting complete, take a close look at the distribution of dark values and bright colors. Is everything in a good balance? If not, you can always glaze on a dark accent or add brighter color.

Color learning point

As I've stated before, repeating color is an excellent way to create harmony. Just be sure to distribute the repeated colors in a way that balances the composition and guides the viewer's eye. Color by color, look at where each one is repeated, constantly attracting to you from one end of the painting to the other and back.

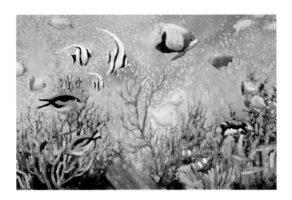

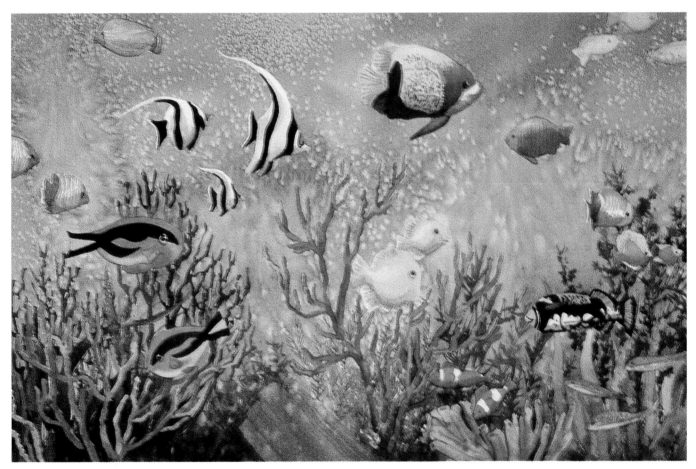

Waterworld, watercolor, 13 x 19" (33 x 49cm) by Dona Abbott ©

Detail

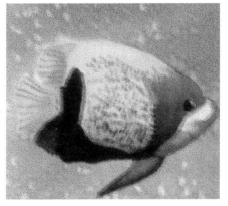

Detail

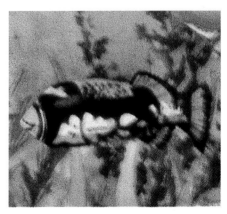

Detail

art map 7

Setting a mood with a single color

Before you begin, read the entire project through so you know what's going to happen next.

A feeling of camaraderie permeates this painting, as the three figures cluster around a paper with news of their former home of China. I felt the image told a story, which is a wonderful quality to have in a work of art. Although the figures were the main focus, it was important to suggest a particular setting by using elements in the background that would not draw too much attention away from the figures.

Balancing the composition and strengthening the central focus in a way that tells a story entails many artistic decisions. As you recreate this painting, you'll learn more about placing a focal point, using positive and negative shapes in a design, using tonal values and contrast to attract and guide the viewer's eye and setting a mood with color.

1. The image to be transferred using the art map.

Read the instructions to see how to map this image across to your paper.

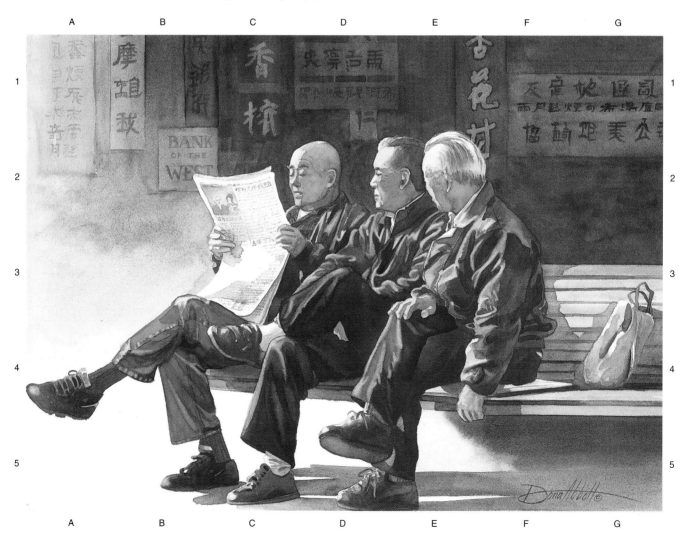

2. Mapping the image

With a 2B pencil, begin by LIGHTLY drawing a grid on your paper that has the exact same number of squares as my grid. Your paper can be the size of my original, or you can choose something proportionally larger or smaller. Your art map will be 6 squares down and 9 squares across. Put in the letters and numbers along the edges to make the next step easier.

3. Use the art map to transfer the image

Now, still drawing very LIGHTLY with your pencil, copy the main contour lines of the objects as shown in each square onto your watercolor paper. It's not necessary to get every detail — just a simple line drawing will do. I recommend LIGHTLY and gently erasing the grid lines in the open, lighter areas before continuing.

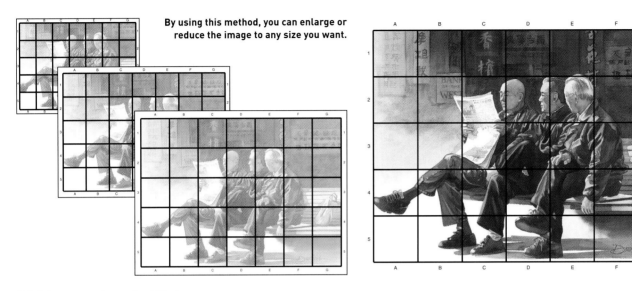

By using this method, you can enlarge or reduce the image to any size you want.

This is how your art map should look.

Here I've done the drawing quite heavily so you can see the idea, but you will do this lightly in pencil.

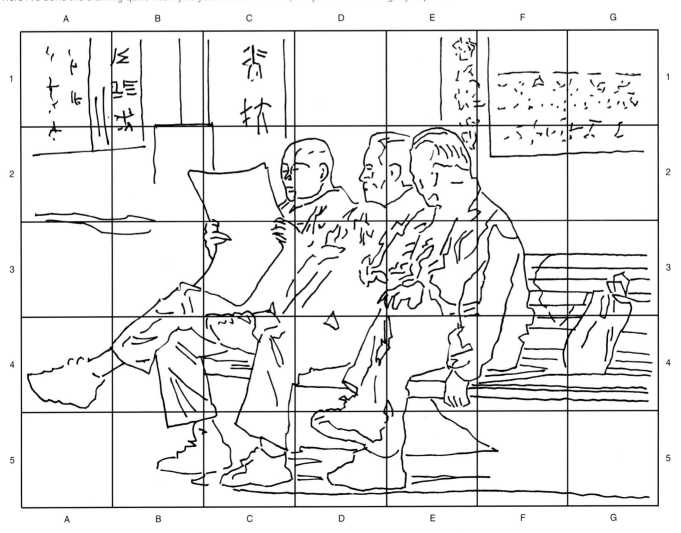

Study these pages before you start painting

Background development

These sketches reveal a great way to develop a background for any subject. At first, I was unsure of what kind of setting to use behind my three figures.

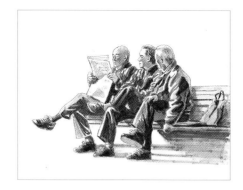

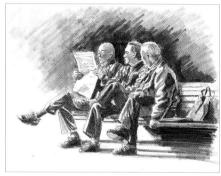

I did a fairly detailed sketch with felt markers in shades of gray plus black, leaving the background empty. Then I made several photocopies so that I could experiment with a number of ideas.

With a soft graphite pencil, I tried a simple value pattern (B). But I felt I wanted to suggest a particular setting — Chinatown.

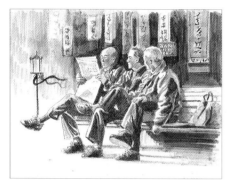

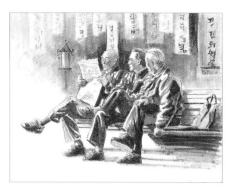

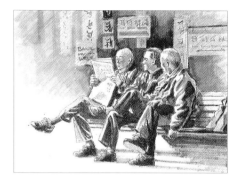

Working from my photo references of signs and other elements from the area, I tried several other layouts involving different configurations.

Notice how in each case, I was looking for ways to use tonal values to offset the figures. I finally settled on this background.

This is a quick and effective way to visualize different background choices. Once you've worked out your design in sketches, you can approach every painting with more confidence.

materials you'll need

paper
300lb (638 gsm) or 140lb (300 gsm) watercolor paper

brushes
2" flat

nos. 4, 8 and 12 rounds

other tools
2B pencil

masking fluid

rubber cement pick-up

facial tissues

your palette for this painting

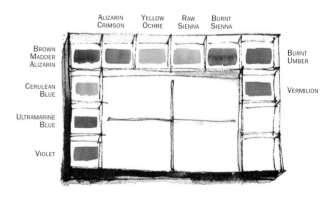

Ask yourself about the following elements

Light source

The newspaper is the focal point of this painting, the center of our interest as well as the focus of the men's attention. (Notice how it's placed on a grid intersection, just like the elk in *Glacier's Guardian*.) Bringing in light from the upper left allowed me to make the paper bright white against the dark background, giving it extreme tonal contrast that is sure to grab a viewer's eye.

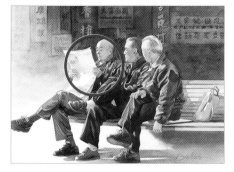

Tonal value map

Notice the unusual outline of the overall shape formed by the three figures. Their heads are light shapes against dark, and their legs are dark against light, which makes the contours stand out. A positive shape (the group of men) interacting with a negative shape (the background) in such an intricate, eye-catching way adds visual interest to a painting.

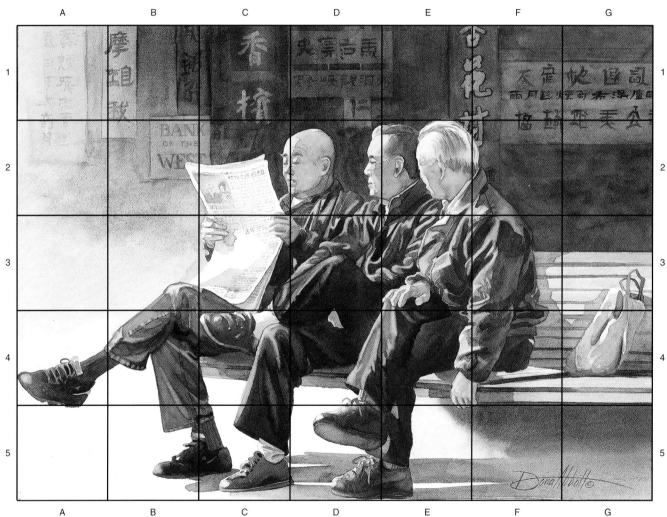

Techniques you'll use

- Preserving whites with masking fluid
- *Floating* wet-into-wet washes
- Wet-on-dry painting
- Lifting color
- Glazing

! Read me

Since watercolor pigment typically dries about 15 to 20% lighter than how it looks wet, it can be difficult to get strong, rich darks.
There are two ways to do this:
- Use less water and more pigment.
- Or, build up the tone with glazes.

Masking

To preserve the whites use masking fluid to protect white and highlight areas. Using an old or inexpensive small, round brush, apply liquid masking fluid over the newspaper and over the two sets of light Chinese characters on the signs in the background. Let it dry thoroughly before continuing.

Putting it all together

4. Paint the heads and hands

Using a small, round brush, apply a base color to the head and hands. As it begins to dry, start to layer on the shadow sides and details. Keep your light source in mind as you paint and watch your values! Let dry thoroughly.

6. Layer in the clothing

Back to the small round brushes to put in the base colors of the clothing. Use a variety of warm and cool blues for interest, but keep the values similar so the three figures read as a single shape. Through layering and glazing, build up the folds and shadows in the clothing. Don't miss that red shirt on the left!

5. Start the background

Begin by laying in some of the rectangular sign shapes, using the warm colors shown. Paint around the lightest Chinese characters. Then, with a larger round brush, carefully apply clear water all along the upper edge of the cluster of figures and bench, extending the water wash across on the left above the angled leg and all the way to the top of the paper. Next, dip the brush into light blues and blue-grays and then touch the pigment-loaded brush into the water. The paint will flow wherever the paper is moist and stop where it is dry, leaving a soft edge. Use very light values on the left and get darker as you move to the right. Watch your values — keep them similar to each other to reduce contrast. You don't want this area to draw attention away from the figures.

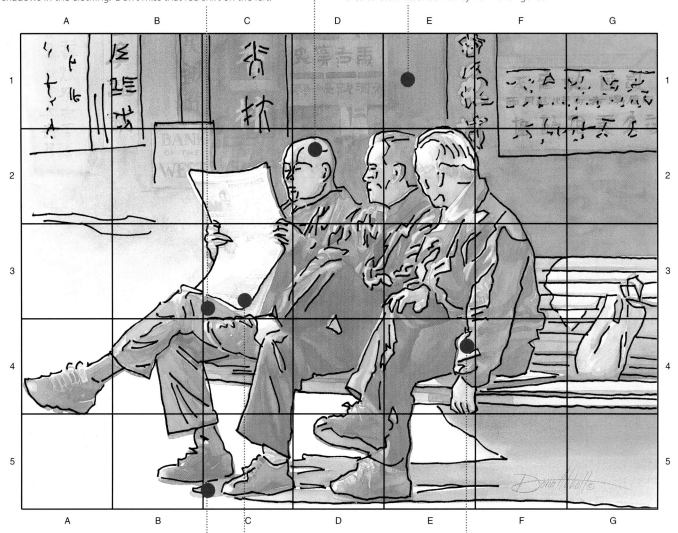

7. Add the bench and cast shadow

Working wet-on-dry with warm earth tones and cool blues, paint in the bench slats and the grocery bag. When that has dried, prepare darker mixes of the same hues to paint the cast shadows. Notice that the shadow just below the bench has a soft edge achieved by going along the colored edge with a brush moistened with clear water. Then paint wet-on-dry to get crisp edges on the shadows cast by the men's legs. At this point, you can use the rubber cement pick-up to lift the masking fluid.

8. Include some detail

It's easy to get carried away with too much detail, so use subdued values to put in the suggestion of text on the newspaper and the Chinese characters on all of the signs in the background. You can always add more or darken them if desired.

9. Finish the background

Look at the painting as a whole to evaluate it. What do you need to do next? If some of the background elements, such as the lettering, seem too distracting, add another light glaze of cool blue to "push" the background back into the distance and soften the edges.

10. Create an eye-path

Now study how well the highlights on the men's heads and clothing, as well as the dark values around the legs, form eye-paths for the viewer to follow. If you've applied too much color and need to restore some highlights, you can lift them out. Use a small brush to apply clean water to the area you want to lift and allow it to soften the pigment somewhat. Then use a facial tissue to blot up the water and excess pigment. Finally, add more dark accents if needed.

Color learning point

The theme of this painting is camaraderie, so every design decision was made to support the idea of unity. Notice, for example, how the three figures overlap to form one shape and how the cast shadows and the background shapes merge to form large shapes. I used color with the same goal in mind.

Inspired by the clothing of the three men, I chose blue as my dominant color, although I used a wide range of warm and cool and light and dark blues for interest. Looking at the color map (right), you can see how the darkest tones link up to form a single, unifying shape. Touches of reds and earth tones in the background, on the bench and in one of the shirts offer balance, some relief from the dominance of blues.

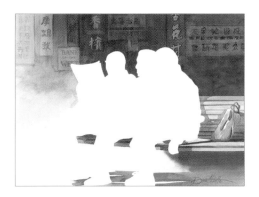

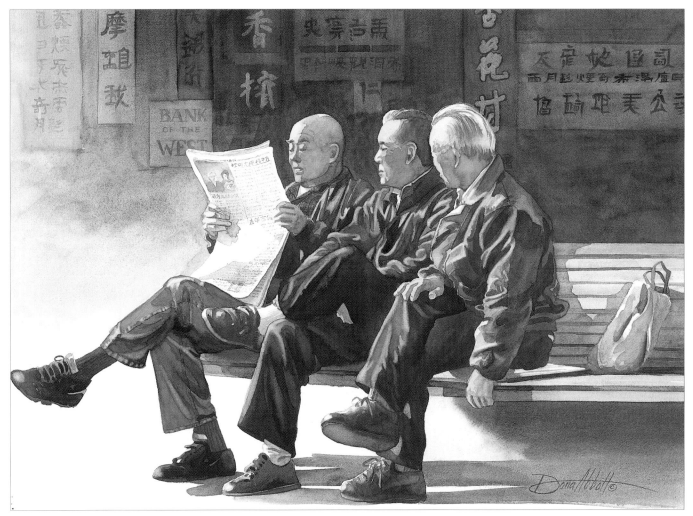

News From Home, watercolor, 22 x 28" (56 x 71cm) by Dona Abbott ©

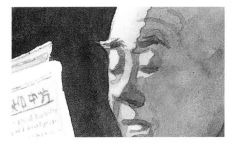

Detail

Detail

Detail

art map 8

Making lively shadow colors

Before you begin, read the entire project through so you know what's going to happen next.

A visit to a quilter friend of mine is never complete without exploring the creative projects underway in her sun-filled sewing room. With its white cubes filled with fabric shelved like books in color groupings, the room is a constant visual treat for my artistic eye. On one visit, the sun streamed in her window, casting interesting shadows from clear containers of sewing notions onto a white table. What great inspiration for a painting!

While there, I snapped a few digital photos. Back in my studio, I photographed some other elements — the antique scissors and a white tape measure — that I felt would enhance the composition. I then imported the images into my computer and used imaging software to arrange the elements, making the most of the shapes, cast shadows and wide range of colors and reflected colors. I could have easily accomplished the same thing using

cutouts of photocopies, much as I did with Project 6 on page 36.

This is what's called a *high-key* (light) painting, one that has predominantly light values. It's a great subject for a watercolor because it takes advantage of the white of the paper. In the process of using pure, bright colors and mixing lively colors for the shadows to recreate this painting, you're going to start to understand something called *reflected light*.

1. The image to be transferred using the art map.

Read the instructions to see how to map this image across to your paper.

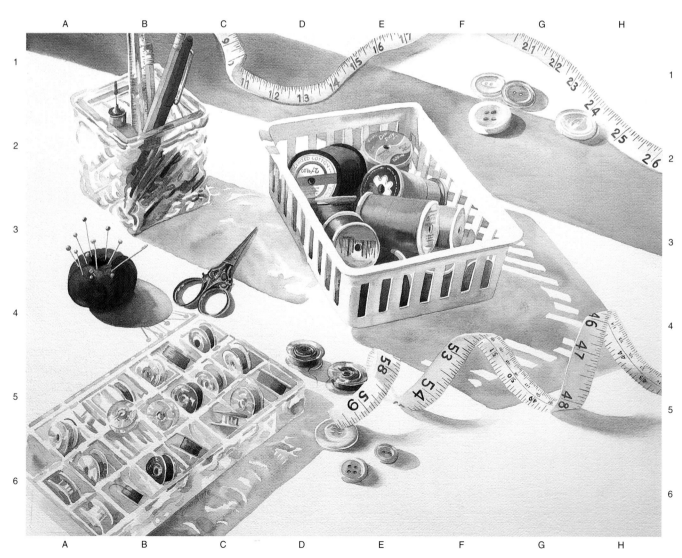

2. Mapping the image

With a 2B pencil, begin by LIGHTLY drawing a grid on your paper that has the exact same number of squares as my grid. Your paper can be the size of my original, or you can choose something proportionally larger or smaller. In my opinion, larger is better because it gives you more room for color variations in the cast shadows. This art map has 6 squares down and 8 squares across. Put in the letters and numbers along the edges to make the next step easier.

By using this method, you can enlarge or reduce the image to any size you want.

3. Use the art map to transfer the image

Now, still drawing very LIGHTLY with your pencil, copy the main contour lines of the objects as shown in each square onto your watercolor paper. It's not necessary to get every detail — just a simple line drawing will do. I recommend LIGHTLY and gently erasing the grid lines in the open, lighter areas before continuing.

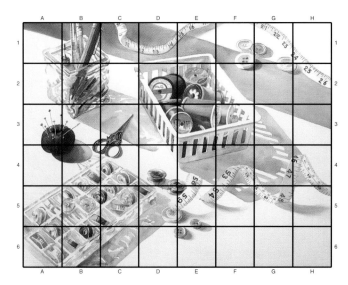

This is how your art map should look.

Here I've done the drawing quite heavily so you can see the idea, but you will do this lightly in pencil.

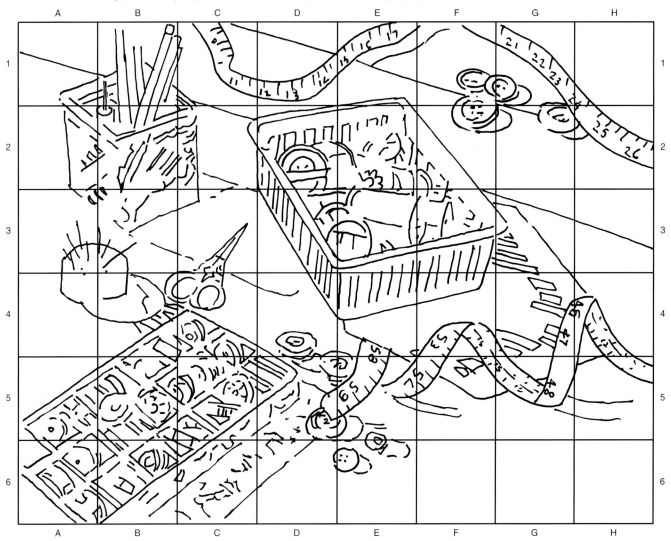

Study these pages before you start painting

Design map
In this composition, three rectangular shapes are linked by shadows, a curvilinear tape measure and some other irregular shapes. Variety! Even more variations can be found in the angles of the bobbins and spools of thread.

Shadow map
Shadows help define the shapes of clear and white objects and link the objects together. The large diagonal shadow cast from something outside the picture space allows the tape measure to create an interplay of positive and negative shapes, adding more visual interest.

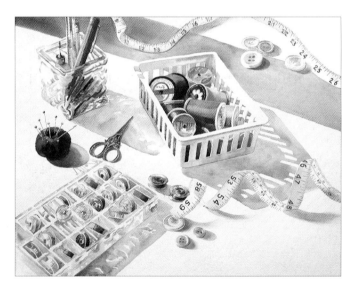

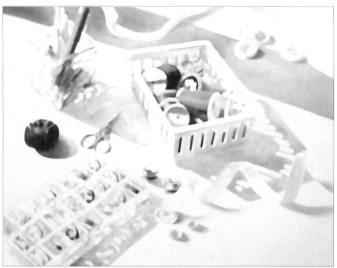

Tonal value map
Notice how much lighter all of the values are compared to other paintings in this book. This is a *high-key* painting. The darkest values are arranged purposely to carry the eye from point to point.

Color map (squint)
Notice how the white-on-white elements make the few bright notes of color stand out — another great example of contrast at work.

materials you'll need

paper
300lb (638 gsm) or 140lb (300 gsm) cold-pressed paper

brushes
2" flat
nos. 4, 8 and 12 rounds

other tools
2B pencil
pen stylus
masking fluid
rubber cement pick-up
masking tape
eraser

your palette for this painting

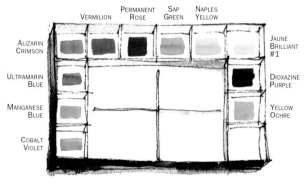

Ask yourself about the following elements

 Light source

The light comes from the rear left of the table, casting shadows that fall diagonally to the right.

 Viewpoint

Viewing this still life from above allows you to show off the exciting shapes of the containers and the colorful objects inside them.

 Bright idea!

Rather than mixing all of your colors on your palette and then applying them, you can apply individual colors within the same wash and let the water do the mixing. You'll get a more varied, interesting look.

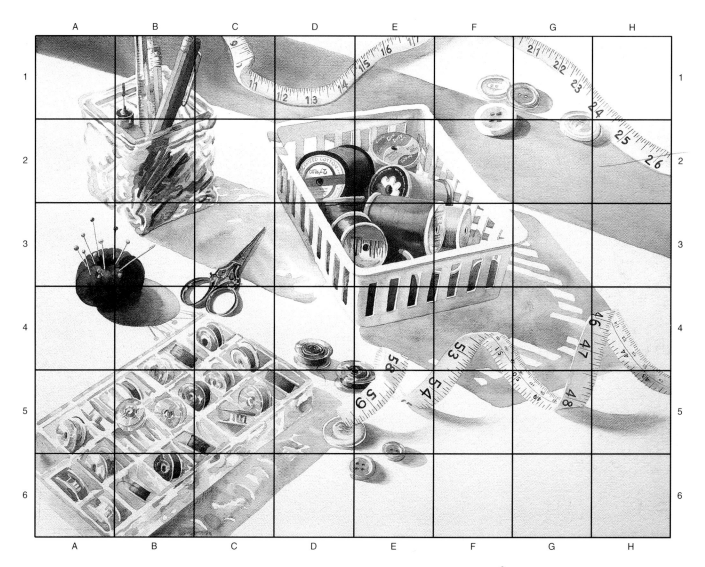

Techniques you'll use

- Preserving whites with masking fluid
- Floating color
- Wet-on-dry painting
- Glazing

 Read me

Because of all the white — the lightest value possible — the colors look darker in value than they actually are. So as you paint, go easy on your values. It's better to go a little light and have to add a glaze than to go too dark and ruin the effect.

 Masking

To preserve the whites use masking fluid to protect white and highlight areas. Apply masking fluid wherever you feel it may be too hard to paint around the whites with a large wash, or wherever you're concerned you might forget to save the whites. Good places: any objects that fall within the cast shadows, the highlights on the pencil container and the white box containing thread. Allow to dry thoroughly before continuing.

Putting it all together

4. Start with the darkest shadow

Use a large brush to wet the entire cast shadow across the top. Then flood in Dioxazine Purple, Ultramarine Blue and Yellow Ochre. Tilt the backing board to encourage the pigments to intermingle. Note that cast shadows are always darkest in value right next to the object casting the shadow, and get progressively lighter as they move away from the object.

5. Cast more shadows

Using the same technique but with lighter values of your shadow colors, paint the cast shadows behind the rest of the objects. Apply the water with care, working around the white shapes or the masking fluid you used. Don't forget the small shadows cast by the buttons and the tape measures.

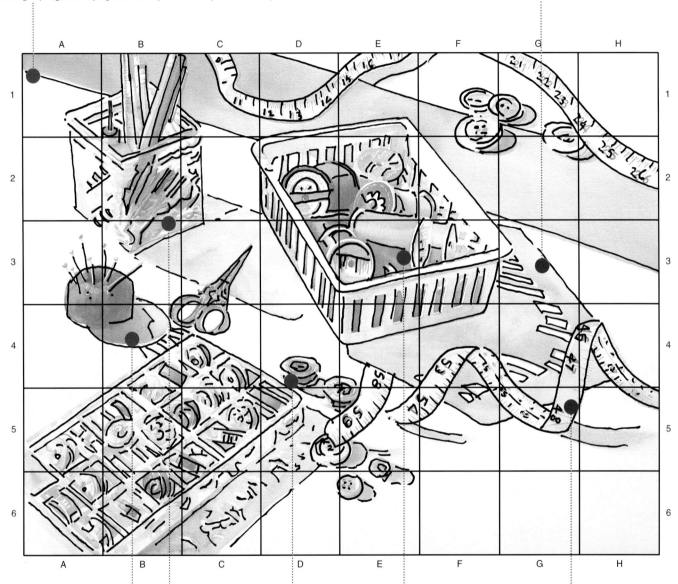

6. Include reflected color

The cast shadow behind the red pin cushion is a great example of reflected light and color. Light is bouncing off the pin cushion, making some of its red color appear in the shadow cast across the white table. Be sure to include some red when you paint this shadow.

7. Paint the pencil cup

Remove the masking fluid from just the pencils, leaving the mask on the highlighted areas of the glass container. Using the same range of warm and cool colors as in the shadows, paint the shadows found within the pencil cup itself and the objects within it. When it's completely dry, remove the remaining masking fluid and add glazes as needed to finish that object.

8. Place the rest of the objects

After removing the rest of the masking fluid, put in the remaining objects. I recommend going slowly, applying a base color to each object, then building up with layers. Glaze over any areas that need brighter color or deeper shadows. Remember the principle of variety and use plenty of colors. Also remember that warm colors advance and cool colors recede.

9. Finish with details

Using your smallest round brush, define the tiny details, such as the pins and the design on the scissors. For the marks on the tape measure, apply the watercolor paint with a dip-style pen nib. A mixture of Ultramarine Blue, Alizarin Crimson, Violet and a little Paynes Gray makes a nice, rich dark.

Color learning point

Color is the element that gives this painting impact. Seen against the crisp, glowing whites, the lively hues of the objects themselves and their cast shadows are sure to catch any viewer's eye.

Why do the cast shadows contain so much color? It comes from a phenomenon called *reflected light*. Light bounces off a brightly colored object, such as the thread, and is reflected in a lighter, softer version onto white and other pale surfaces. Reflected color is particularly visible in the shadows. Many beginners are tempted to see and paint cast shadows as simple grays, but if you learn to train your eye, you'll begin to see all sorts of beautiful, reflected colors in any light subject. Slightly exaggerating them will help the painting grab even more attention.

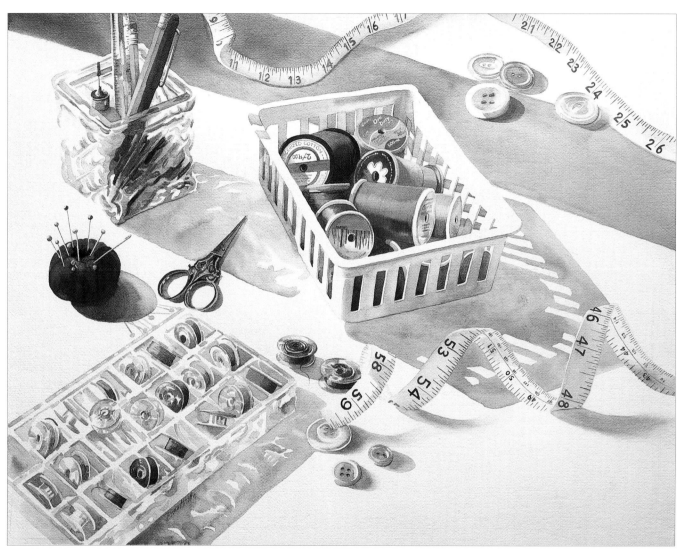

A Stitch in Time, watercolor, 21¹/₂ x 27¹/₂" (55 x 70cm) by Dona Abbott ©

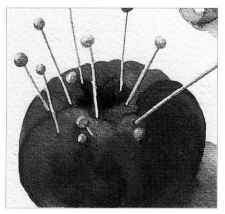

Detail

Detail

Detail

art map 9

Understanding analogous color

Before you begin, read the entire project through so you know what's going to happen next.

Everyone has childhood dreams. This painting is about a little girl's dream of becoming a ballerina, but it evokes the innocent hope of childlike fantasies and wishes, which is a universal quality that everyone can relate to. I placed these well-worn ballet slippers on a musical score of Tchaikovsky's *Swan Lake* to express that dream-like feeling.

This romantic, feminine color scheme offers a change of pace from the projects so far, which I hope you'll enjoy. Your skill level will definitely be enhanced by the challenge of painting the wrinkled satin surface of the shoes and the fine lines on the sheet music.

1. The image to be transferred using the art map.

Read the instructions to see how to map this image across to your paper.

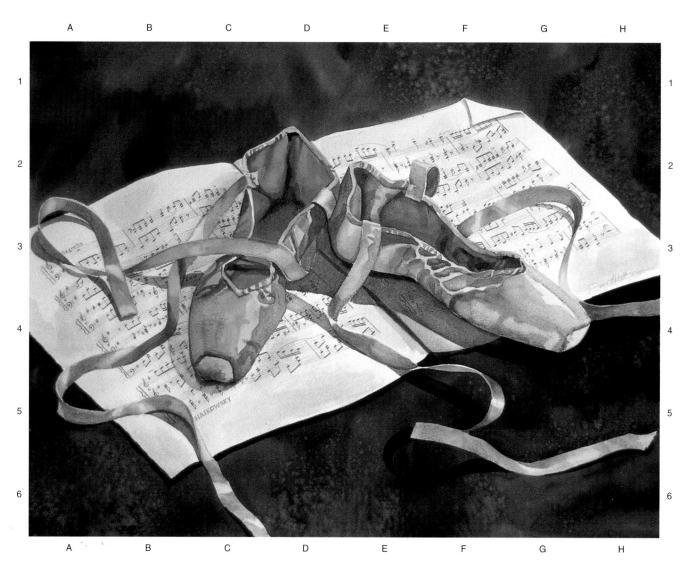

2. Mapping the image

With a 2B pencil, begin by LIGHTLY drawing a grid on your paper that has the exact same number of squares as my grid. Your paper can be the size of my original, or you can choose something proportionally larger or smaller. This art map has 6 squares down and 8 squares across. Put in the letters and numbers along the edges to make the next step easier.

By using this method, you can enlarge or reduce the image to any size you want.

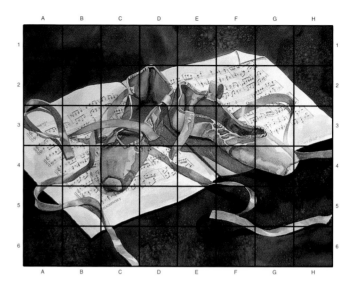

3. Use the art map to transfer the image

Now, still drawing very LIGHTLY with your pencil, copy the main contour lines of the objects as shown in each square onto your watercolor paper. It's not necessary to get every detail — just a simple line drawing will do. I recommend LIGHTLY and gently erasing the grid lines in the open, lighter areas before continuing.

This is how your art map should look.
Here I've done the drawing quite heavily so you can see the idea, but you will do this lightly in pencil.

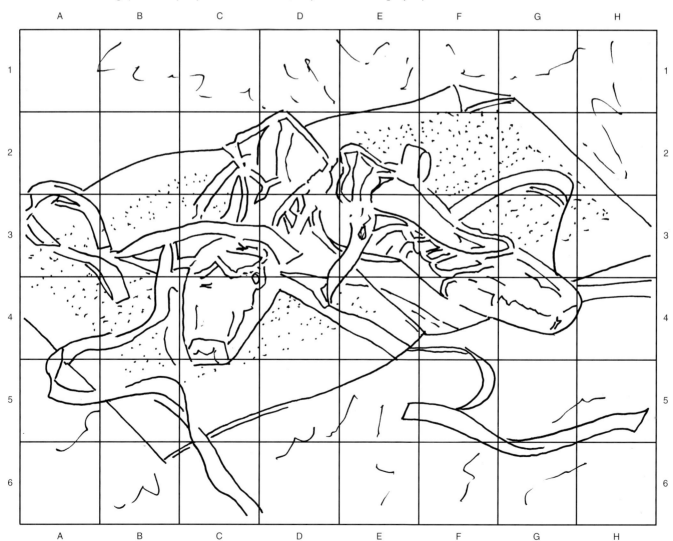

Study these pages before you start painting

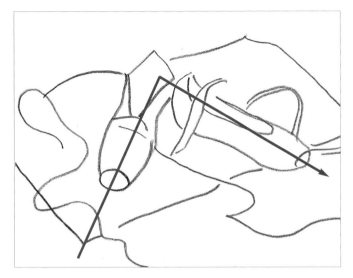

Movement map
Although the shoes are centered in the composition, they are placed at angles and allowed to touch at the heels so that they form a more interesting shape. The sheet music and ribbons extending beyond the edge of the page provide entry points for the eye, and the curving ribbon helps guide the eye around the painting and back to the ballet slippers.

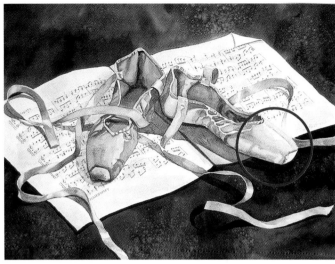

Tonal value map
The highest point of contrast is around the toe of the shoe on the right — the lightest highlight against the darkest cast shadow. However, there are many secondary points of value contrast guiding the eye.

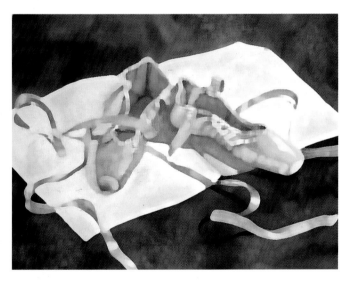

Color map (squint)
The analogous color scheme of orange, red (and its derivative, pink) and purple becomes quite visible when seen here. Analogous colors are any three colors that lie next to each other on the color wheel.

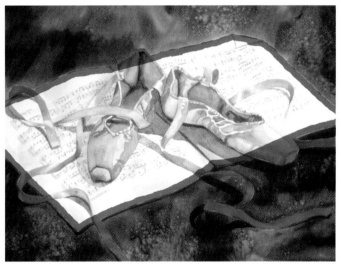

Masking fluid guide
Protect your brush by rubbing it onto a bar of ordinary soap first before dipping it into the masking fluid. Apply the masking fluid as shown. This will allow you to be very free with the wet-into-wet background wash. When finished, clean the brush well with soap and cool water.

materials you'll need

paper
140lb (300 gsm) cold-pressed watercolor paper

brushes
3" and 1" flats
nos. 4, 8 and 12 rounds

other tools
2B pencil
table salt
spritzer bottle filled with water
masking fluid
rubber cement pick-up
facial tissues

your palette for this painting

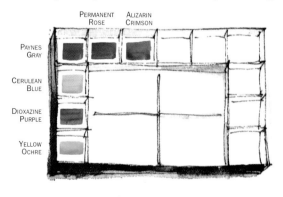

PERMANENT ROSE · ALIZARIN CRIMSON
PAYNES GRAY
CERULEAN BLUE
DIOXAZINE PURPLE
YELLOW OCHRE

Ask yourself about the following elements

 Light source

Here, the light is coming from the right, almost directly from the side. Keep this in mind when placing the highlights on the ribbons and on the satin shoes, and note the angle of the cast shadows.

 Bright idea!

If you prefer the look of clean, straight edges bordering your painted image, before you begin painting, tape off the edges with masking tape. You might want to use a straightedge to pencil in a taping guide first to make sure you create a perfect rectangle. When the painting is completely dry, pull the masking tape off slowly at an angle so it won't tear the paper.

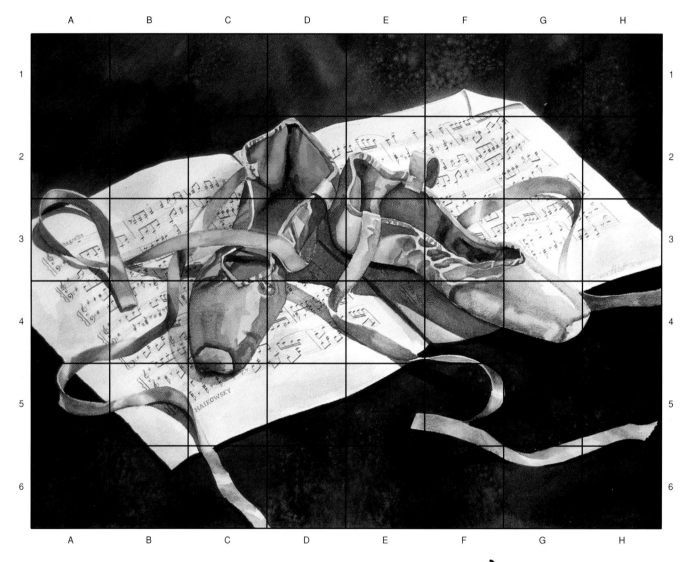

Techniques you'll use

· Preserving whites with masking fluid
· Large wet-into-wet wash
· Wet-on-dry painting
· Lifting color
· Glazing

 Read me

Hot water is too harsh for washing brushes. It can damage the glue inside and ultimately loosen the bristles. Always use cool water to wash your brushes.

 Masking

To preserve the whites use masking fluid to protect white and highlight areas. Following the instructions and guide on the previous page, apply masking fluid to the painting. Make sure it's thoroughly dry before continuing.

Putting it all together

4. Lay the background wash

Wet the entire upper and lower portions of the background with clean water. Then float in dark values of Dioxazine Purple and Alizarin Crimson, plus a few touches of Ultramarine Blue and Permanent Rose, and tilt the board to let the color mingle. Just as the sheen begins to fade, sprinkle table salt over the wet pigment to create a gentle texture. When the background is completely dry, you can remove the masking fluid.

5. Tint the paper

You'll want the sheet music to have some varied color, but it should be extremely light. Wet the entire area, right over the shoes and ribbons, with clean water. Then float in very watery Paynes Gray and drop in PALE touches of Permanent Rose and Alizarin Crimson.

6. Start the shoes and ribbon

Mix up a large quantity of pale Permanent Rose, and cover the shoes and ribbons with this light wash. While the pigment is still wet, layer on darker values of the same color mixed with Alizarin Crimson and Cerulean Blue to suggest some soft-edged shadows where appropriate. Remember your light source as you do this!

7. Create the satin finish

To suggest a satin finish make distinct value changes between highlights and shadows. You also want the shoes to look worn and broken in. To achieve both of these effects, use Dioxazine Purple and Cerulean Blue to glaze in the darkest shadow shapes wet-on-dry. This will create hard edges, giving the illusion of a shiny, yet wrinkled, surface. To restore some of the highlights where needed, use clean water to soften the pigment and blot with a tissue.

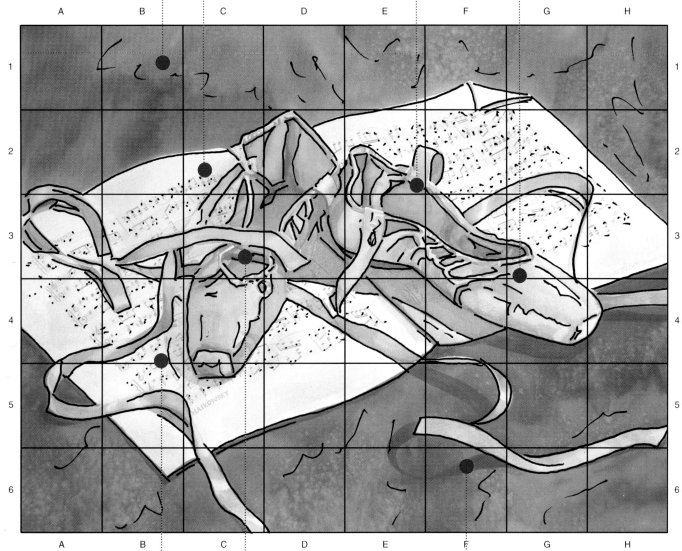

8. Master the music

Now it's time to put in the music notes. Use a tiny brush to apply fine lines of Paynes Gray. To prevent the brush from releasing an unsightly blob, touch a paper towel to the base of the brush ferrule (where it joins the bristles) to soak up excess water in the brush before touching it to the paper. If strokes get too dark, simply blot them with a tissue or paper towel just before they dry.

9. Shift colors inside the shoes

To paint the interiors of the shoes, use the same pinks but add Yellow Ochre to create a pink-tinged orange. Layering on some darker tones for shadows while the initial wash is still wet will create soft edges. The change in color and edges will accentuate the difference in textures between the satiny surface and the lining.

10. Cast a few shadows

You'll need a darker mixture of Dioxazine Purple, Paynes Gray and Alizarin Crimson to paint in the shadows cast by the ribbons and the paper. Apply wet-on-dry.

Color learning point

In several of the previous projects, we've used repeated color to create harmony. But that's just one of several ways to unify a painting with color. Here we use *analogous* colors, which are any three colors that lie next to each other on the color wheel. Unlike complementary colors, which visually clash and create a dramatic vibration, analogous colors naturally look good together, creating a peaceful, harmonious, elegant effect.

Since pink is generally a light version of red, it qualifies as the red in this orange-red-purple color scheme. Be aware that I used both warm and cool variations of these colors, plus a few other hues, to make the painting more appealing.

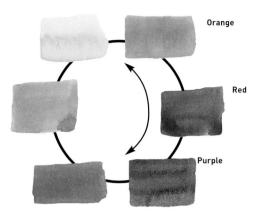

Orange

Red

Purple

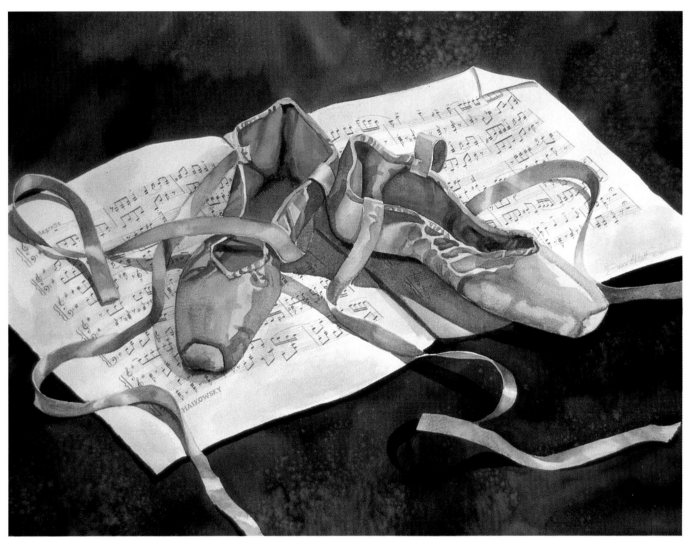

Swan Lake — Lori's Dream, watercolor, 20 x 28" (51 x 71cm) by Dona Abbott ©

Detail

Detail

Detail

art map 10

Stepping up to split complements

Before you begin, read the entire project through so you know what's going to happen next.

On a visit to my sister's house, I became enthralled with her koi pond. I was fascinated by the way the fish would nibble the food out of my hand with what felt like little kisses. Before long, I realized that each fish had its own distinct look and personality. What fun it would be to capture their lively activity and bright color in a natural setting. Sometimes I think that the most successful paintings grow from this kind of enthusiasm.

As you've progressed through these projects, I'm sure you've noticed that each one is a little more complex and sophisticated. This painting is no exception. I'm doing this intentionally so that you gain experience and build confidence in your abilities. So tackle this project with gusto and be adventurous. You just may surprise yourself.

This time, you're going to learn about an advanced type of color harmony called *split complements*. You're also going to explore a composition that creates a sense of movement by arranging the shapes and positions of the fish and ripples in the water. And your end result will suggest a world beyond the confines of the painting through the artful use of reflections and perspective (the waterlilies continuing into the distance).

1. The image to be transferred using the art map.

Read the instructions to see how to map this image across to your paper.

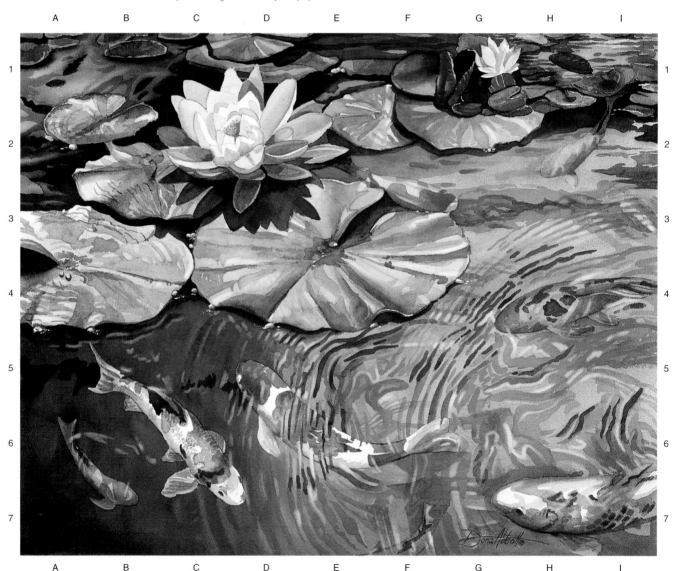

2. Mapping the image

With a 2B pencil, begin by LIGHTLY drawing a grid on your paper that has the exact same number of squares as my grid. Your paper can be the size of my original, or you can choose something proportionally larger or smaller. This art map has 6 squares down and 9 squares across. Put in the letters and numbers along the edges to make the next step easier.

3. Use the art map to transfer the image

Now, still drawing very LIGHTLY with your pencil, copy the main contour lines of the objects as shown in each square onto your watercolor paper. It's not necessary to get every detail — just a simple line drawing will do. I recommend LIGHTLY and gently erasing the grid lines in the open, lighter areas before continuing.

By using this method, you can enlarge or reduce the image to any size you want.

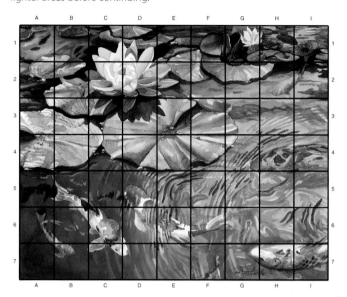

This is how your art map should look.

Here I've done the drawing quite heavily so you can see the idea, but you will do this lightly in pencil.

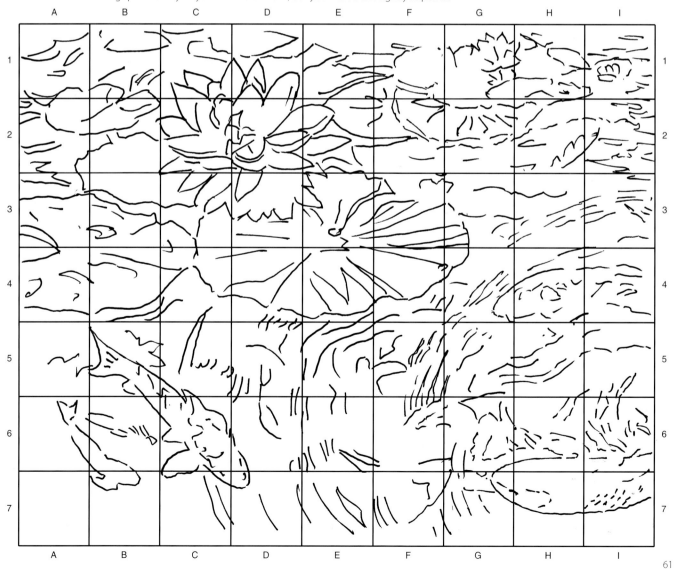

Study these pages before you start painting

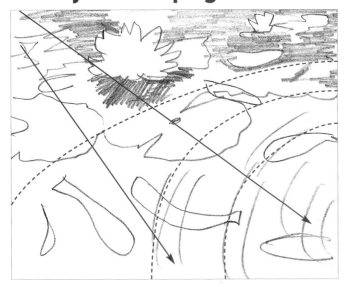

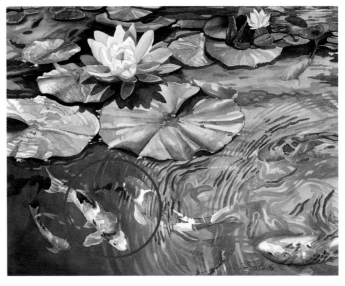

Design and shape map

Movement was my goal right from the start. The ripples moving up and to the left are intersected by the fish and lilies moving down and to the right, causing tension. I tried several layouts of the fish and foliage in different curves and positions before finding the composition that worked.

Focal point guide

Strong contrast is a magnet for the eye. Because of its high contrast against the foliage and water, the white waterlily stands out the most, which is why I positioned this primary focal point near one of the sweet spots. I then put two bright, high-contrast fish in another sweet spot to create a secondary focal point.

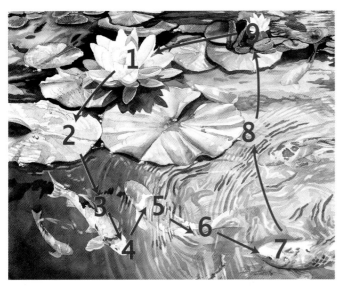

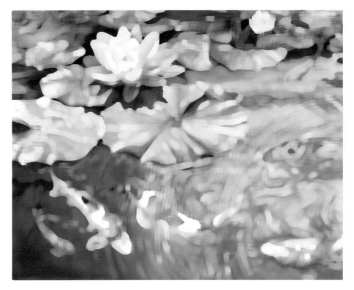

Movement map

Look at the light values in this painting. Notice how your eye jumps from one light to another, moving in a circle. Elsewhere in the painting, the values are quite similar so that these elements flow gently together. The darkest values in the water suggest water depth.

Color map (squint)

Color contrast gives you a visual jolt and contributes to the active feeling of a painting. That's why I used contrasting colors here — red-orange and red (as seen in the pink) are the opposite of blue and blue-green.

materials you'll need

paper

300lb (638 gsm) cold-pressed watercolor paper

brushes

2" flat

nos. 4, 8 and 12 rounds

¾" oval

other tools

2B pencil

masking fluid

rubber cement pick-up

paper towels

your palette for this painting

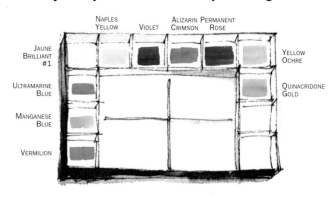

Ask yourself about the following elements

Light source

This is a tricky one — the lighter values of the water on the right may deceive you. Look at the shadows and you'll see that the light is actually coming from the upper left.

Viewpoint

Making the viewpoint at this level above the pond creates a unique perspective. Notice how the waterlilies diminish in size as they move off into the distance. Because we see the lilies drifting off the top edge of the paper, we have the feeling that they continue on into the distance.

Bright idea!

You can create the illusion that something is further in the distance by using less detail, diminishing size and cooler colors. All of these devices tend to push elements back. Or, deeper, in the case of the fish.

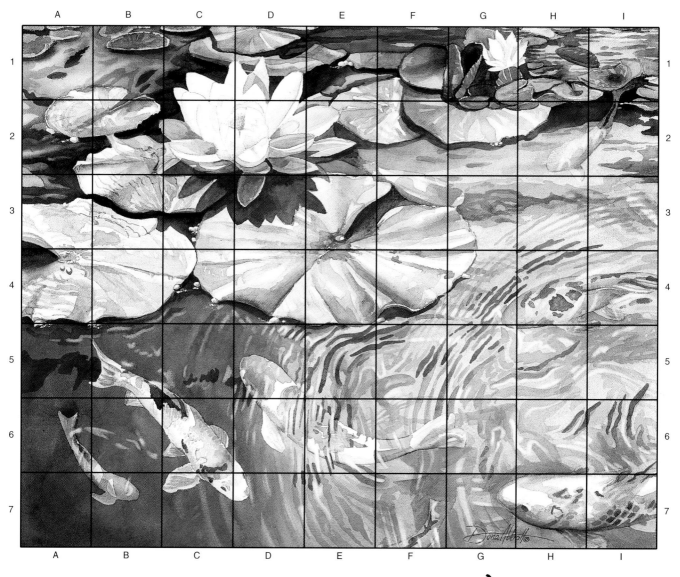

Techniques you'll use

- Preserving whites with masking fluid
- Large wet-into-wet washes
- Lifting color with a variety of methods
- Wet-on-dry painting
- Glazing

Read me

When you're painting a repeated element, such as these disc-like waterlily pads, it's easy to fall into the trap of painting them all alike. But in nature, no two objects are ever identical. Always make each object slightly different. Not only is it more realistic, it's more interesting for the viewer.

Masking

To preserve the whites use masking fluid to protect white and highlight areas. Using an old or inexpensive brush, apply masking fluid over the fish and the two waterlilies. Allow it to dry thoroughly before continuing.

Putting it all together

4. Lay a blue base wash

Wet the entire paper except for the lilies and pads, using a ³/₄" oval wash brush to work around the complex shapes. Lay in different shades of blue and green, varying the color temperatures throughout the water and getting darker on the far left. Let this dry completely before continuing.

5. Intensify the water

In this step, you will concentrate on darkening the water surrounding the waterlilies on the left and across the top. With a large brush, apply clean water up to the edge of the waterlilies, then float the color into the water. Building the depth of the color in successive glazes will help prevent hard edges from appearing. Allow each glaze to dry thoroughly before adding another layer.

6. Paint the lily pads

Using a variety of both warm and cool greens, plus touches of a few other related colors (dark orange-red on the upper right), paint the lily pads. Remember the direction of the light source and place your shadows and highlights accordingly. Apply some layers wet-into-wet and others wet-on-dry to create both soft and hard edges. The cool tones will harmonize with the water, while the warm tones add variety.

7. Put in the lilies

When the painting is completely dry again, remove the masking fluid with a rubber cement pick-up. Working wet-on-dry, apply light washes of Alizarin Crimson and Permanent Rose to build up the forms within the white waterlilies. A yellow-orange works well for the large lily's center.

8. Create the fish

Use several variations of red-orange to paint the fish, including the hidden fish in the lower left corner. For the multi-colored fish, create neutral shadow colors by mixing various combinations of the colors you've been using. Notice that the two large fish on the lower left have far more detail and shading than the others.

9. Add the details and shadows

When the paint has dried, it's time to glaze on the small details throughout the painting. Use a dark mixture of Alizarin Crimson, Ultramarine Blue and Violet to put in the near-black spots on some of the fish. Use slightly lighter variations in different proportions of the mixture for all of the shadows cast by the lilies and lily pads. Next, apply wet-into-wet glazes of blues for soft-edged ripples and wet-on-dry glazes for hard-edged ripples. Some ripples can also be lifted by softening with clean water and blotting.

10. Apply a final glaze

To make some of the fish, such as the one in the lower left, appear to be deeper down in the water, glaze over the fish and the water with a blue wash. Do this quickly and with a light touch to avoid disturbing the underlying layers of color.

Color learning point

If you recall the second project, you'll remember the theory behind complementary colors. These are colors that lie across from each other on the color wheel. Because they're opposites, they tend to clash, which is something you can use to your advantage when you want an active, dynamic, dramatic color scheme.

This painting's color scheme is built on the same principle, but it's taken to a higher level of sophistication. These are *split complements,* two side-by-side colors (in this case, blue and green) and the mixed color that lies across from them (red-orange).

Why do the pink tones of the main waterlily fit in well? Pink is derived from red, so it's related to the red-orange. At the same time, it's a cool pink so it fits in with the cool blues and blue-greens. Here, pink adds to the exciting balance of color.

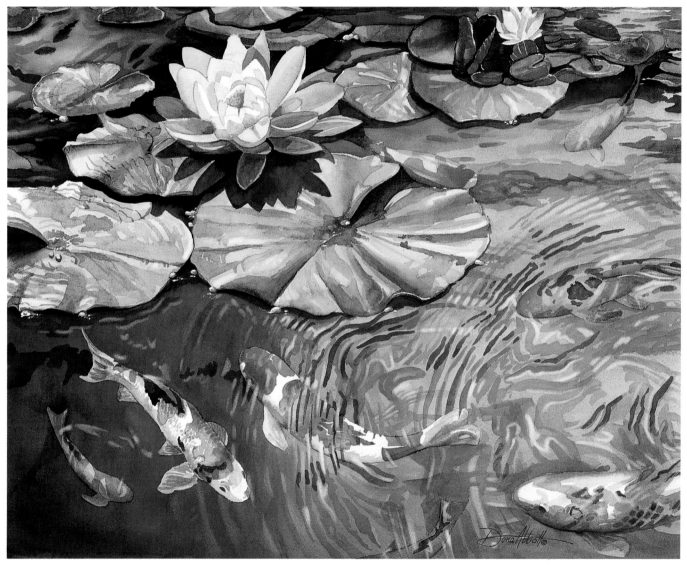

Good Vibrations, watercolor, 20 x 26" (51 x 66cm) by Dona Abbott ©

Detail

Detail

Detail

art map 11

Using tints and shades

Before you begin, read the entire project through so you know what's going to happen next.

All artists occasionally need to challenge themselves with new color schemes, and this painting was one such challenge for me. I was commissioned to paint a Colorado landscape to hang in a room of a high-tech firm. On a hard-hat tour to view the interior space where the painting would hang, I was shocked to see walls in five strong colors converging in the designated area. What was I to do? How could I create a painting that would fit in?

I decided to take inspiration from the five wall colors, shown below. Visualizing their related tints (lighter values) and shades (darker values), I realized the hues evoked my favorite time of day — dawn, when the first rays of the sun play across the landscape. I decided to paint my mountain scene in this light. This pushed me into using a different color scheme than the photos I took as my references. The challenge stretched my artistic vision and yielded a unique end product.

This project taught me a valuable lesson: If you find yourself in a rut, pick a color you haven't used before and incorporate it into a painting. Explore the various ways you can lighten it, darken it and mix it with other colors. You can also break out of your comfort zone by borrowing a color scheme from some other source, such as a fabric swatch, a photograph or an advertisement.

1. The image to be transferred using the art map.

Read the instructions to see how to map this image across to your paper.

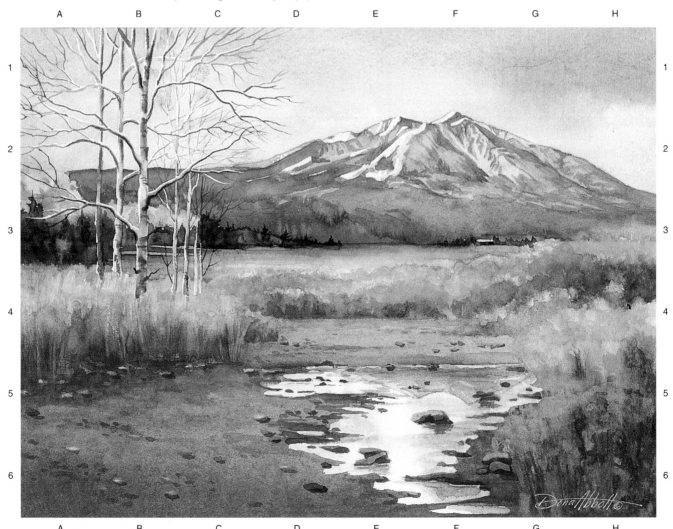

2. Mapping the image

With a 2B pencil, begin by LIGHTLY drawing a grid on your paper that has the exact same number of squares as my grid. Your paper can be the size of my original, or you can choose something proportionally larger or smaller. This art map has 6 squares down and 8 squares across. Put in the letters and numbers along the edges to make the next step easier.

3. Use the art map to transfer the image

Now, still drawing very LIGHTLY with your pencil, copy the main contour lines of the objects as shown in each square onto your watercolor paper. It's not necessary to get every detail — just a simple line drawing will do. I recommend LIGHTLY and gently erasing the grid lines in the open, lighter areas before continuing.

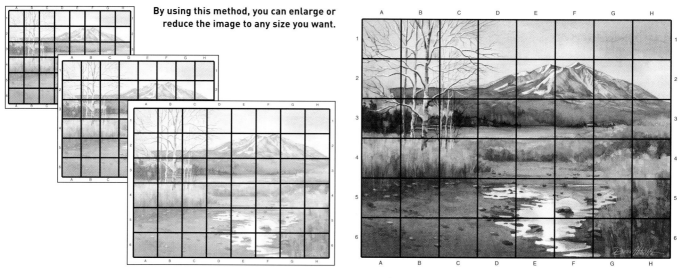

By using this method, you can enlarge or reduce the image to any size you want.

This is how your art map should look.

Here I've done the drawing quite heavily so you can see the idea, but you will do this lightly in pencil.

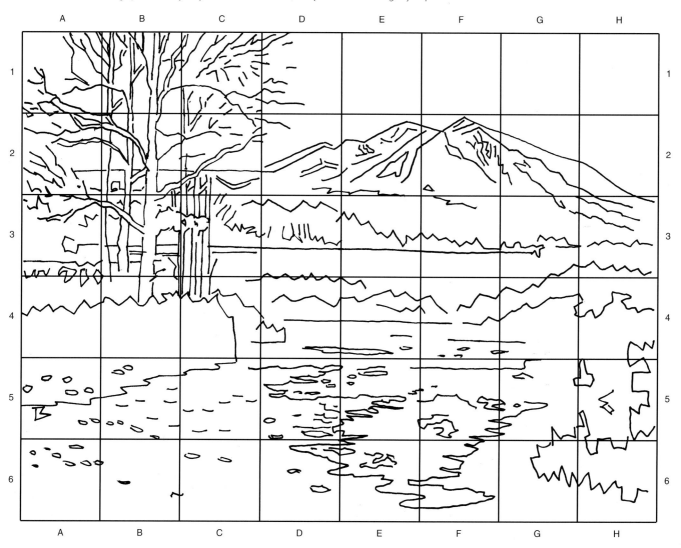

Study these pages before you start painting

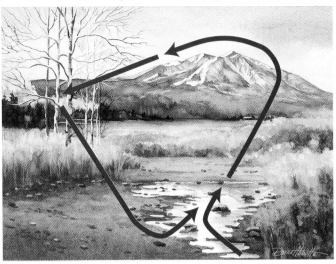

Design and shape map
I used strong horizontal lines to create a feeling of peaceful, pre-dawn calm and serenity. The vertical trees break up the monotony of the horizontals and direct the eye to other elements.

Tonal value map
Looking at this black-and-white version, you can see just how similar the values are throughout most of the painting — mostly mid-values. This is what sets the quiet mood of the piece. However, the few light values really stand out, and you can see how they lead your eye into and around the painting. The few dark values are strategically placed to balance one another. Notice how the weak light casts few shadows.

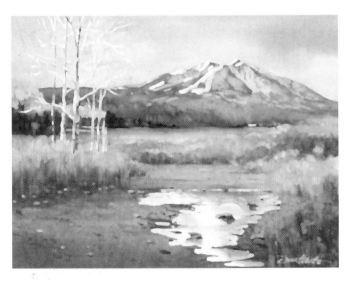

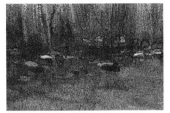

Level of detail
Notice how there is very little fine detail anywhere in the painting. Why? At this hour of the morning, you wouldn't be able to discern much, so everything is SUGGESTED rather than clearly defined.

Color map (squint)
Seen this way, you understand what an important role the foreground water plays. Not only does it strengthen the composition, it echoes the colors used elsewhere. Repeated color creates harmony.

materials you'll need

paper
300lb (638 gsm) cold-pressed watercolor paper

brushes
3" flat
nos. 4, 8 and 12 round
rigger or script brush
³/₄" oval

other tools
2B pencil
spritzer bottle filled with water
natural sponge
masking fluid
rubber cement pick-up

your palette for this painting

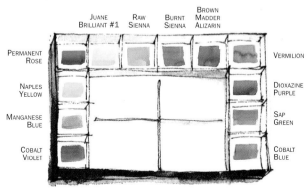

Ask yourself about the following elements

Light source

In the early morning, the sun is still low in the sky, which means it tends to skip over the highest points of the various elements. Morning light is also rather weak, so in general you will see softer, neutral colors in a fairly limited range of predominantly middle values.

Viewpoint

A peaceful mood requires a balanced composition. Notice how this particular viewpoint allowed me to align elements in perfect balance.

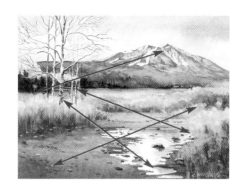

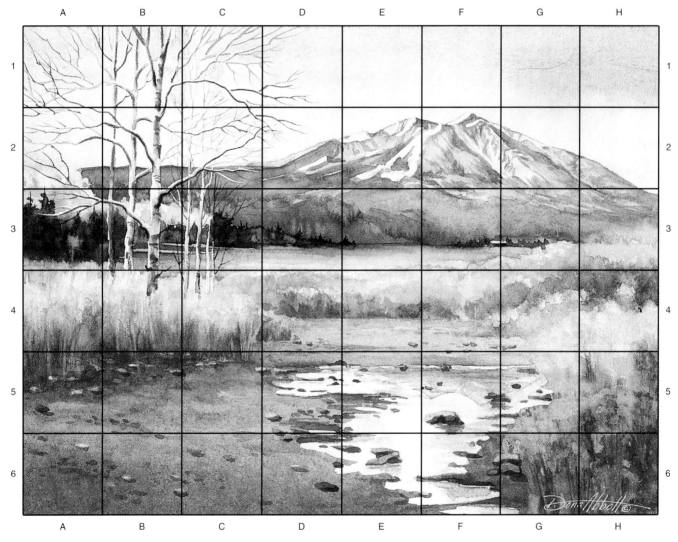

Techniques you'll use

- Preserving whites with masking fluid
- Large wet-into-wet washes
- Wet-into-wet painting
- Wet-on-dry painting
- Glazing
- Creating textures with a variety of methods

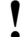

Read me

If you're painting a subject that involves some lighter, softer colors, you might want to choose pigments such as Jaune Brilliant, Cerulean Blue and Naples Yellow. Because they contain a little white, they impart a milky softness to washes and mixtures with other colors.

Masking

To preserve the whites use masking fluid to protect white and highlight areas. With an old or inexpensive round brush, protect the tree trunks, a few larger branches and the water puddle with masking fluid. You can paint around the whites of the snow when you paint the mountain.

Putting it all together

4. Lay in the land

With the exception of the distant stands of yellow and dark green trees, wet the entire lower portion of the paper. Rather than mixing a single color on your palette, drop in light complementary colors to create a livelier gray — yellows, oranges, blues and purples — and tilt your surface. Keep it lighter in the distance and darker in the foreground to create depth.

5. Paint the mountain

When the sky is completely dry, lay a light wash of blue over the entire mountain, except the white highlights in the snow. Drop in a little pale yellow toward the left. As the wash begins to dry, start building up the shadowed areas with slightly darker blues. Working wet-on-dry, glaze in the strongest, hard-edged shadows on the left, and carry that glaze down over the entire base of the mountain. Spritz with clean water to create subtle texture.

6. Fly through the sky

With a large brush, wet the entire sky area with clean water, bringing the water right up to the edge of the mountain. Flood in light tints of yellows and pink-oranges along the left horizon, then add light and mid-value blues as you move right. Tilt your backing board to make the colors flow and mingle.

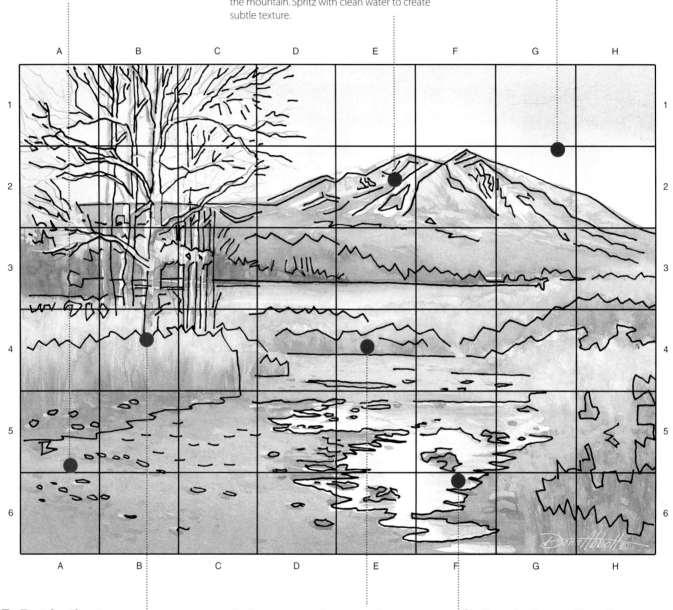

7. Put in the trees

Working wet-on-dry, put in the distant stand of golden trees. While this is still wet, add the dark blue-green trees below. As this dries, add a few touches of detail with slightly crisper edges. Don't forget the extra stand on the right horizon. Lift out the light roof.

When these have dried completely, remove the masking fluid and paint the aspens. Work light to dark and warm to cool. Layer the colors on in quick succession so you get soft edges.

8. Layer and texturize the foliage

While this wash is still wet, start putting in the various layers of vegetation. Drop yellow-green in along the horizon. Then add yellow and purples to the grassy areas. As these begin to dry, layer on more color by applying the pigment with a natural sponge. Scratch into some foreground areas with the hard handle-tip of the brush. These techniques will create soft, muted textures that suggest grasses.

9. Catch the reflection in the water

Remove the mask from the puddle. Most of the water's surface should reflect the sky color except where it mirrors the mountain. Finally, accentuate the rocks' shadows with small glazes of any of the dark neutrals used elsewhere. These darks help to anchor the foreground.

Color learning point

This commissioned painting was designed to fit the specific situation and place in which it was meant to hang. When I saw what bright colors would be surrounding it, I knew I couldn't compete with that intensity. Instead, I decided to go in the opposite direction, using softer, more neutral variations of the same colors. The swatches to the right show how I combined some bright pigments to create neutrals.

My color scheme also required mixing tints and shades of my main colors.

A tint is a light value of any particular color, typically created by adding plenty of water to the pigment.

A shade, on the other hand, is a darker value of a color, which often requires the addition of a second dark, neutral color.

Manganese Blue

Brown Madder Alizarin

Ultramarine Blue

Brown Madder Alizarin

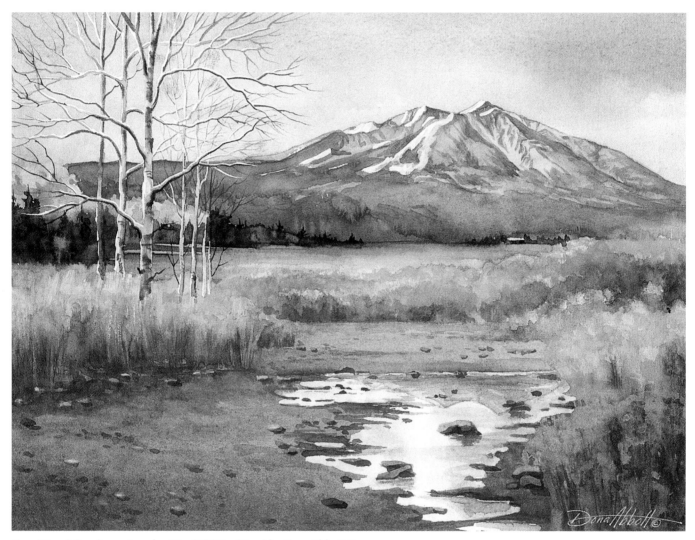

Mount Sopris Sunrise, watercolor, 16 x 22" (41 x 56cm) by Dona Abbott ©

Detail

Detail

Detail

art map 12

Painting a subdued color scheme

Before you begin, read the entire project through so you know what's going to happen next.

The glow of early evening, just after the sun has gone down, is one of my favorite times of day. In winter, the setting sun often kisses the twigs and bare branches with an orange glow, making the trees look as if they're wearing haloes. And when the snow is on the ground and the cold numbs your nose and toes, there is nothing quite so heartening as seeing the welcoming, warm lights of home.

With these particular qualities in mind, I looked through my extensive collection of photos of architecture and chose a typical farmhouse as the starting point for a new piece.

This painting would not convey the mood and feel of this particular moment without all of these special characteristics, and the same is true of any painting. So the purpose of this project is to provide you with an opportunity to practice using a variety of techniques to create a specific atmosphere.

Most important, you're going to deal with a subdued color scheme and discover how to paint a white subject — snow! But along the way, you'll also learn to paint an architectural element, and you'll use some new tools and another application technique called *drybrushing* that's ideal for creating texture.

1. The image to be transferred using the art map.

Read the instructions to see how to map this image across to your paper.

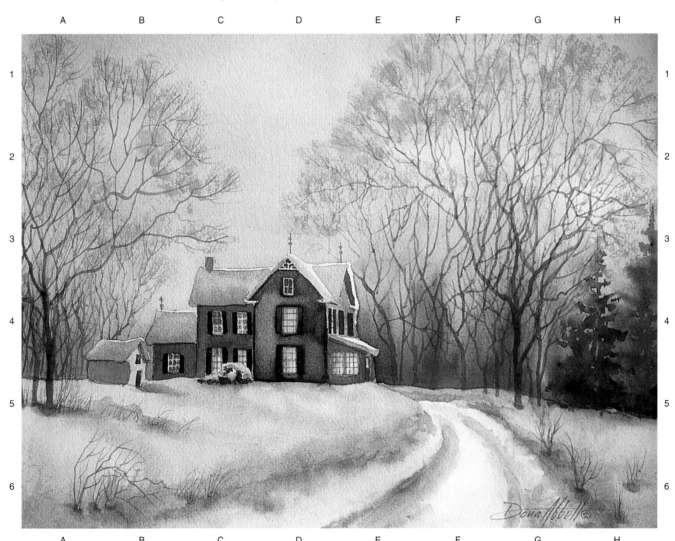

2. Mapping the image

With a 2B pencil, begin by LIGHTLY drawing a grid on your paper that has the exact same number of squares as my grid. Your paper can be the size of my original, but you may want to go a little larger so you have more room to work with. Your art map should have 6 squares down and 8 squares across. Put in the letters and numbers along the edges to make the next step easier.

By using this method, you can enlarge or reduce the image to any size you want.

3. Use the art map to transfer the image

Now, still drawing very LIGHTLY with your pencil, copy the main contour lines of the objects as shown in each square onto your watercolor paper. It's not necessary to get every detail — just a simple line drawing will do. I recommend LIGHTLY and gently erasing the grid lines in the open, lighter areas before continuing.

This is how your art map should look.
Here I've done the drawing quite heavily so you can see the idea, but you will do this lightly in pencil.

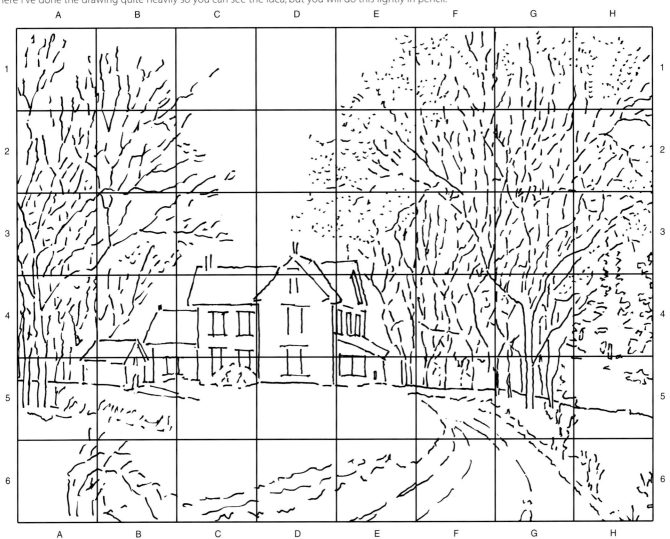

Study these pages before you start painting

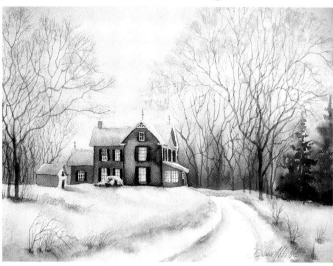

Design and shape map
The composition is divided into three zones — sky, middle ground and foreground. The design is strengthened significantly by making each of these zones different sizes and shapes.

Tonal value map
Just as we saw in the previous project, without a strong, direct light source, the value range becomes very narrow and there are few cast shadows. However, to create the illusion of depth and keep the viewer's attention on the focal point. Subtle shifts in tonal values between the three zones are needed.

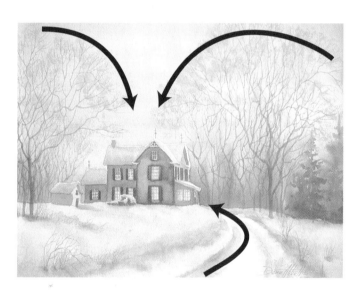

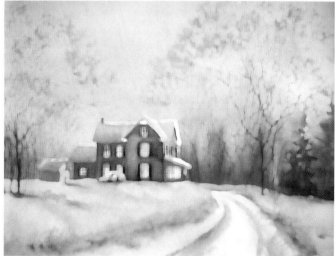

Movement map
The curves in this design serve two purposes. First, they all lead the eye into the focal point and around the painting. Second, they reinforce the sense of depth in a three-dimensional space.

Color map (squint)
This painting plays warm hues against cooler tones. The color scheme engages viewers by allowing them to sense the growing cold and feel the warm promise of the house.

materials you'll need

paper
140lb (300 gsm) cold-pressed watercolor paper

brushes
1" and 2" flats
nos. 6, 8 and 12 rounds
rigger or script brush

other tools
2B pencil
masking fluid
rubber cement pick-up

your palette for this painting

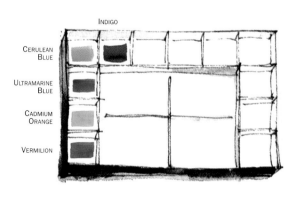

INDIGO

CERULEAN BLUE

ULTRAMARINE BLUE

CADMIUM ORANGE

VERMILION

Ask yourself about the following elements

Light source

The primary light source for this painting is the setting winter sun, which casts a very weak light, darkening the values throughout. The lights inside the house provide a second light source, casting a warm glow over the snow outside the windows.

Viewpoint

This vantage point places the house slightly above your line of sight. What effect does this have on the mood of the painting and your response to it?

Bright idea!

Drybrushing means blotting some of the pigment out of your brush before dragging it lightly over the paper. The brush will hit only the high spots in the paper and release very little paint, creating a rough texture in the stroke. Experiment with the different effects you can get by holding the brush at various angles.

more pigment released

less pigment released

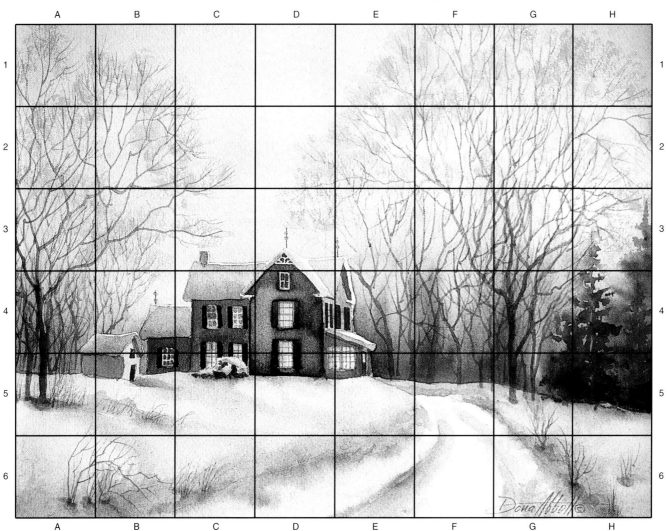

Techniques you'll use

- Preserving whites with masking fluid
- Large, graduated wash
- Wet-into-wet painting
- Wet-on-dry painting
- Glazing
- Drybrushing

! Read me

Saving a white shape with masking fluid often results in a very hard edge around it. To soften a hard edge, use a soft brush to apply a little clean water along the edge. This softens and blurs the pigment. Blot the excess water with a facial tissue or paper towel.

Masking

To preserve the whites use masking fluid to protect white and highlight areas. Using an old or inexpensive brush, apply masking fluid over the house and garage, including the little shrubs immediately in front of the house.

Putting it all together

5. Suggest sundown

With a large brush, wet the top two-thirds of the paper (sky and background trees) with clear water. Drop in light Vermilion at the top, then work down through Cadmium Orange, adding more and more water as you go to get lighter toward the horizon. The change will enhance the feeling that the sun has gone down while strengthening the sense of perspective.

6. Suggest background trees

While the sky wash is still damp, start putting in the background trees on both sides of the house using light washes of Ultramarine, Cerulean Blue and Indigo. As the paper dries, add another medium-value layer of trees. When the washes are fairly dry, put in a few more trees on the far right with a fairly dark mix. Gently roll or twist the brush as you lay down the strokes to create silhouetted branches.

7. Play in the snow

Wet the bottom one-third of the paper with clean water and drop in very pale washes of Ultramarine, Cerulean Blue and Indigo. Include some Cadmium Orange because the white will reflect some of the sky color. While the wash is still wet, put in darker strokes to create the road and the dips in the snow. Put in a hint of a cast shadow wherever you plan to have twigs emerging from the snow. Don't forget to add the orange glow outside the windows.

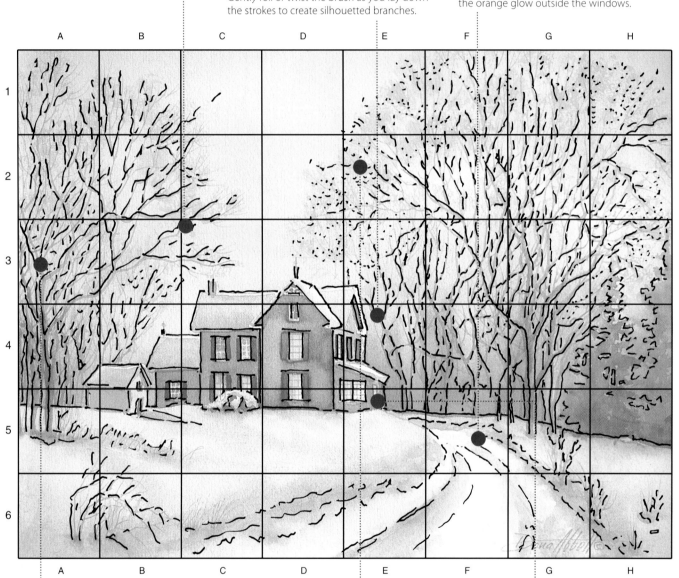

8. Use a fine-point brush for branches

The bare trees in the middle ground should be painted with the same blue-grays for harmony, but warmed up slightly with Vermilion and Cadmium Orange to make them come forward in the painting. Use a small round brush or a long, pointed rigger or script brush. Start each stroke at the base of the trunk or branch and gently ease off the pressure as you glide out to the end of the stroke. This will ensure that the heaviest paint is at the weightiest roots and that the lightest, finest strokes are at the thinnest branch tips.

9. Drybrush the treetops

Use a fairly dark mix of Vermilion and Cadmium Orange for those dried leaves left on the trees. To give them a textured, airy appearance, use the *drybrushing* technique. Load a flat brush with wet pigment, run the bristles along a paper towel to absorb much of the paint and then lightly drag short strokes along the branch ends. Add a second layer in just a few places for more variety.

10. Paint the house

When the painting is very dry, remove the masking from the house. Working wet-on-dry and dealing with each small shape individually, apply the same colors you've been using to paint the house. Be sure to vary the colors seen in each window for added realism and interest.

Color learning point

One of the earlier projects, *A Stitch in Time* on page 48, provided you with an opportunity to paint white objects as seen in bright, direct sunlight. This painting contains a white subject shown in weak twilight. Compare the two experiences. You'll no doubt realize two things: White objects tend to reflect the colors around them. The shape of white objects is defined by their shaded sides and cast shadows. Ultimately, there is no one right color to use to paint white. It all depends on the light and the color of the other objects surrounding the white element.

Detail

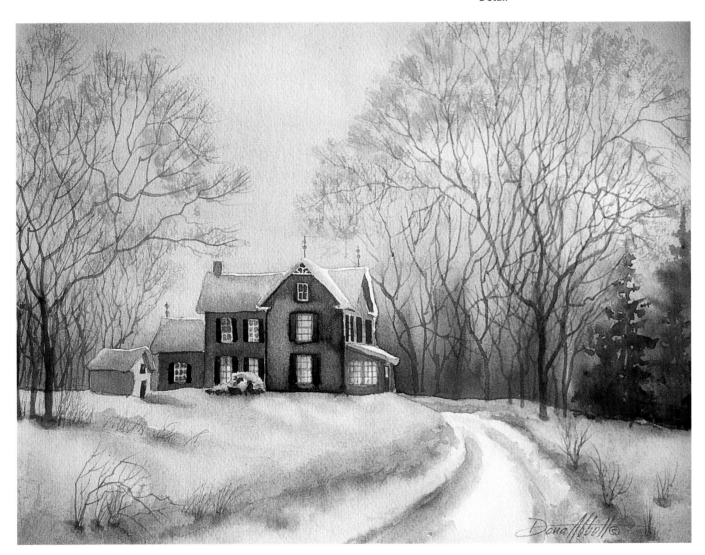

Home for the Holidays, watercolor, 8¹/₂ x 10" (22 x 26cm) by Dona Abbott ©

Detail

Detail

Detail

art map 13

Creating color harmony

Before you begin, read the entire project through so you know what's going to happen next.

Endlessly fascinating, the sea tugs at me irresistibly. Walking along the beach, sand sliding between my toes, rhythmic waves washing the shore, sea gulls screeching — this is one of the greatest delights in life. I was inspired by the effect of the early morning sun on the pier and the irony of the weak little electric lights giving way to the more powerful sun. This painting captures the breathtaking subtlety of the impact of the sun on the hues of the ocean and wet sand. Moments of beauty like this last a lifetime.

Because the soft mood and early time of day are the main elements of this painting, very little detail is needed. The picture works because of the strong value changes, and yet the total range of values is limited because of the low light.

With this project, you will experience controlling your values and practice creating color harmony, once again by echoing the sky colors elsewhere in the picture. Glazing will help you suggest the movement of the water, and lifting techniques will help you indicate the wet sand while enhancing the soft mood.

1. The image to be transferred using the art map.

Read the instructions to see how to map this image across to your paper.

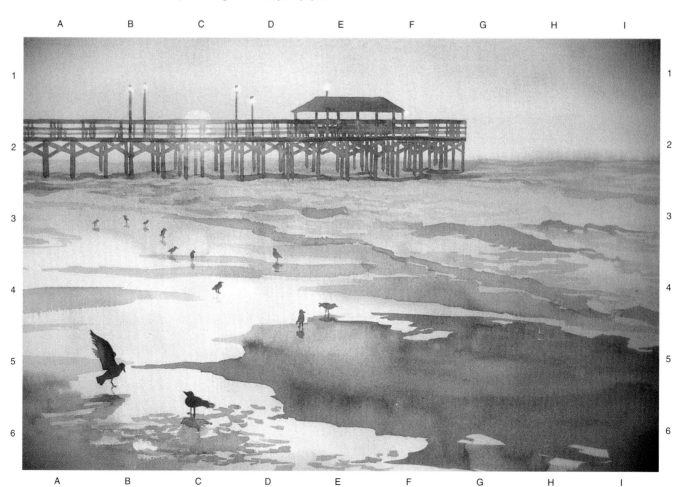

2. Mapping the image

With a 2B pencil, begin by LIGHTLY drawing a grid on your paper that has the exact same number of squares as my grid. Your paper can be the size of my original, or you can choose something proportionally larger or smaller. This art map has 6 squares down and 9 squares across. Put in the letters and numbers along the edges to make the next step easier.

3. Use the art map to transfer the image

Now, still drawing very LIGHTLY with your pencil, copy the main contour lines of the objects as shown in each square onto your watercolor paper. It's not necessary to get every detail — just a simple line drawing will do. I recommend LIGHTLY and gently erasing the grid lines in the open, lighter areas before continuing.

By using this method, you can enlarge or reduce the image to any size you want.

This is how your art map should look.

Here I've done the drawing quite heavily so you can see the idea, but you will do this lightly in pencil.

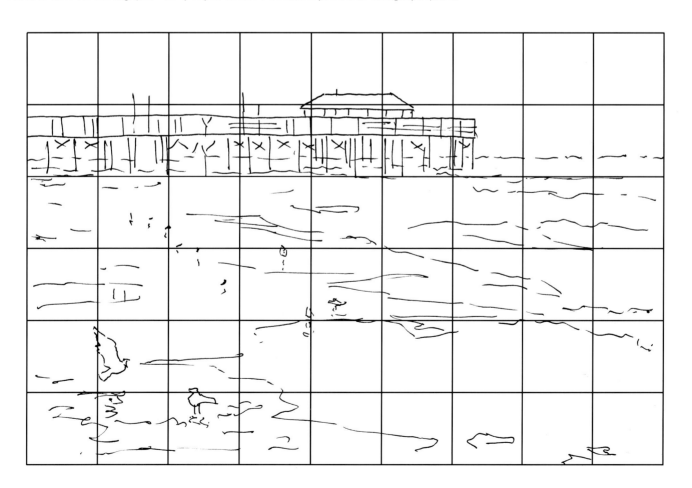

Study these pages before you start painting

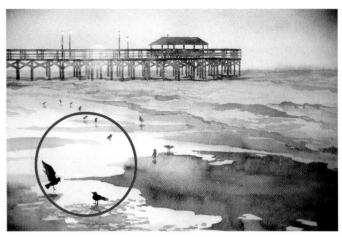

Design and shape map
When you break the composition down, you can see how the lights and darks work together. As if placed on an X, the foreground and background shapes balance each other, adding to the tranquil mood. The darker-value waves connect the back to the front, and the dark shapes in each of the two lower corners prevent the eye from leaving.

Focal point guide
Look for the highest degrees of tonal value contrast, and you'll discover they both fall near the sweet spots. Other, less obvious areas of contrast guide your eye in a circular path around the painting.

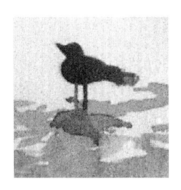
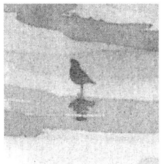

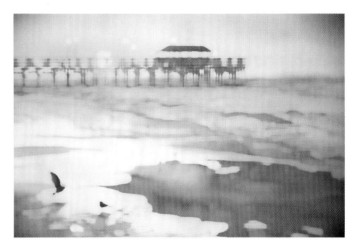

Perspective pointers
If you've got an element that repeats into the distance of your subject, such as these seagulls, they should become smaller as they get further away. Compare these two same-size details, and notice how the distant birds are much smaller than the close birds. In reality, they're the same size, but the size change creates depth in the painting.

Color map (squint)
If you squint to study the composition, you'll see how the color of the sky impacts the other elements in the painting. Squinting also reveals how the sun's focused, intense light almost makes the pier immediately in front of it disappear.

materials you'll need

paper
140lb (300 gsm) cold-pressed watercolor paper

brushes
1" flat

nos. 6, 8 and 12 rounds

no. 2 square-tipped brush

small bristle brush

other tools
2B pencil

tissue-covered thread spool (see Art Map 2)

your palette for this painting

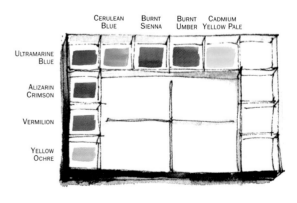

Ask yourself about the following elements

 Light source

Looking at the sun itself, it's a very bright, intense light that nearly blots out the object in front of it. However, because the sun is so low in the sky, it doesn't cast much light over the subject, which makes for a fairly narrow range of tonal values.

 Viewpoint

Placing the horizon high in the picture allowed me to show off the beautiful shapes and colors of the wet sand and ocean.

 Bright idea!

Some pigments have a stronger staining power than others, which makes them more difficult to lift up again. However, one color that lifts easily off the paper is Manganese Blue. If you foresee doing a lot of lifting, you might want to mix a little of this pigment in with your other colors to make the process easier.

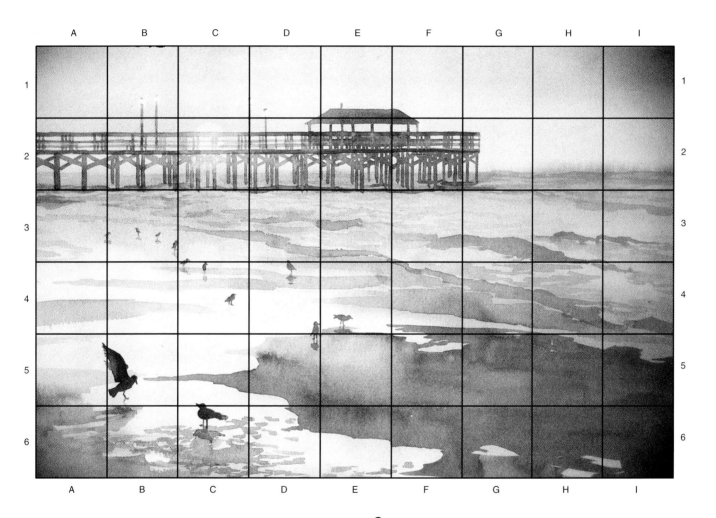

Techniques you'll use

- Large, graduted wet-into-wet washes
- Lifting color with a variety of methods
- Wet-into-wet painting
- Wet-on-dry painting

 Read me

Really look closely at the tonal values in this painting and you'll see how the many gradations add subtle interest. On the one hand, you want to keep the range fairly limited to suggest the early morning light and peaceful mood. But you don't want to go too far and have basically one or two values throughout the entire painting. A painting with too few tonal values and too little contrast is bound to be boring.

Putting it all together

4. Lay a warm foundation

With your largest flat brush, wet the entire sheet top to bottom with clean water. Starting at the top, float in warm Yellow Ochre and Cadmium Yellow Pale near the location of the sun. When this is dry, wet the paper again and add just a hint of Cerulean and Alizarin Crimson on the far right, away from the sun. Continue this process down the entire paper, keeping the yellow tones toward the left and center and adding pinks and pale blues around the outer edges. Allowing the paper to dry between washes will prevent the yellow and blue from combining to make green.

5. Lift the sun

Remember the tissue-wrapped thread spool from Project 2 on page 15? Use it again here to lift off the shape of the sun while the pigment is still wet. Or you can use an oil painter's bristle brush to soften the paint, then blot with a tissue to lift off the color.

6. Glaze the ocean and sand

As the initial wash begins to dry, start to layer on the soft-edged pinks and blues in the ocean, just below the horizon line. When the wash is really dry, glaze darker blues and lavenders in hard-edged shapes toward the foreground. The large shape in the right foreground is a combination of Ultramarine Blue and Burnt Umber. Spritz some clean water over this large shape as it dries to create subtle texture.

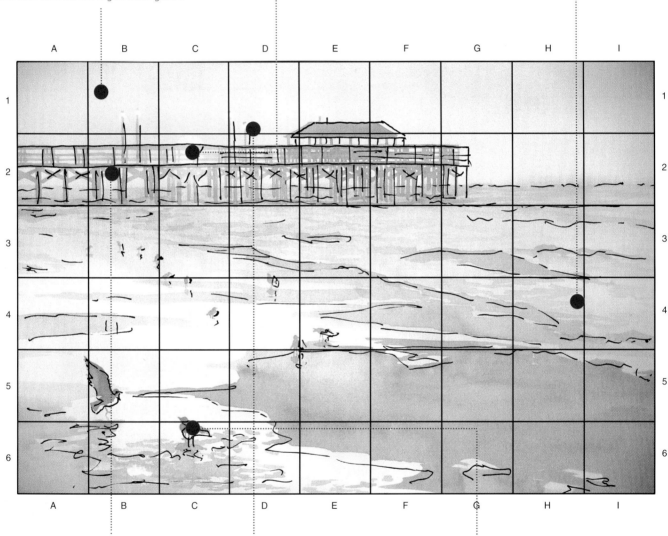

7. Paint the pier

Using various combinations of Burnt Sienna and Burnt Umber and a smaller round brush, paint the shapes of the pier. Since this is a silhouette, there is no need for detail or value/color changes. Paint straight through the lamp posts, top to bottom.

8. Light the lamps

With a small, round bristle brush, apply clean water just below the top of each lamp post. Work the water around in a small circle. When the pigment has softened, use a facial tissue or paper towel to blot up the excess water and loose pigment.

9. Add the birds

When the painting is quite dry, use the same Burnt Umber/Ultramarine Blue mixture to paint the silhouettes of the birds. Use a lighter value of the same mix for their cast shadows. If you take care with the shapes of the foreground birds, you will then need less definition with the distant birds. Your viewers will easily identify the close-up birds as gulls and make the connection that all of the silhouettes are the same birds.

Color learning point

Color in a painting doesn't always have to be brilliant and intense to grab a viewer's attention. Sometimes the subtleties and nuances of a scene can evoke a specific time of day or atmospheric effect that soothes and pleases in a more gentle, yet equally powerful, way.

In this project, relatively few pigments are used and the resulting color mixes are all closely related. What makes the painting interesting is the way modest warms and cools are placed against each other and the way the various tonal values interact.

Detail

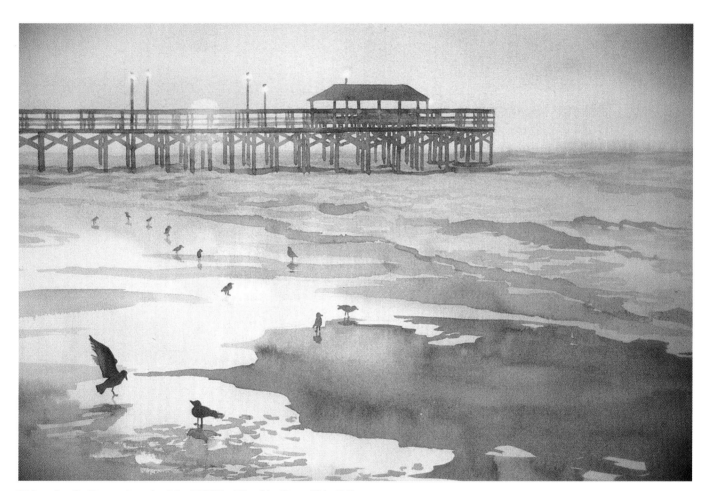

Welcoming the Day, watercolor, 15 x 22" (38 x 56cm) by Dona Abbott ©

Detail

Detail

Detail

art map 14

Going all neutral

Before you begin, read the entire project through so you know what's going to happen next.

Traveling in a rickety boat down a river in Cambodia, my peripheral vision caught something up on the high banks above me. I turned to find these bikers nearly silhouetted against the light sky, which fascinated me. I took plenty of photographs so that when I returned to the studio, I could recreate the excitement of my first impression of this scene.

Placing the horizon line high on the page was a surefire way to add drama to the scene. Have you ever noticed how Academy Award-winning directors use this technique in movies? There's a good lesson there: Creative approaches that work in other artistic media are often equally effective for paintings.

Since the excitement of this painting is based on the interesting shapes of the cyclists and the contrast of darker values against the light sky, I decided to subdue some of the other elements, such as color. Once again, I used the complements of blue and orange, but this time I mixed them to make harmonious neutrals. A few notes of pure colors, plus some subtle textures, provide extra sparks of interest for the viewer.

1. The image to be transferred using the art map.

Read the instructions to see how to map this image across to your paper.

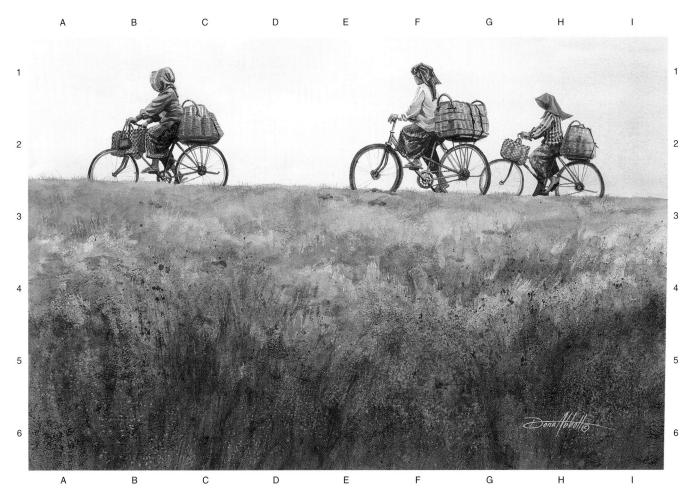

2. Mapping the image

With a 2B pencil, begin by LIGHTLY drawing a grid on your paper that has the exact same number of squares as my grid. Your paper can be the size of my original, or you can choose something proportionally larger or smaller. This art map has 6 squares down and 9 squares across. Put in the letters and numbers along the edges to make the next step easier.

3. Use the art map to transfer the image

Now, still drawing very LIGHTLY with your pencil, copy the main contour lines of the objects as shown in each square onto your watercolor paper. It's not necessary to get every detail — just a simple line drawing will do. I recommend LIGHTLY and gently erasing the grid lines in the open, lighter areas before continuing

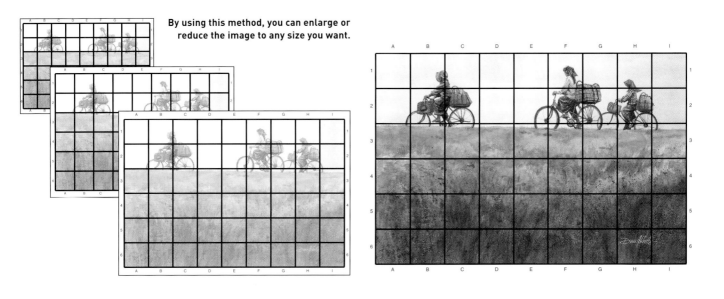

By using this method, you can enlarge or reduce the image to any size you want.

This is how your art map should look.

Here I've done the drawing quite heavily so you can see the idea, but you will do this lightly in pencil.

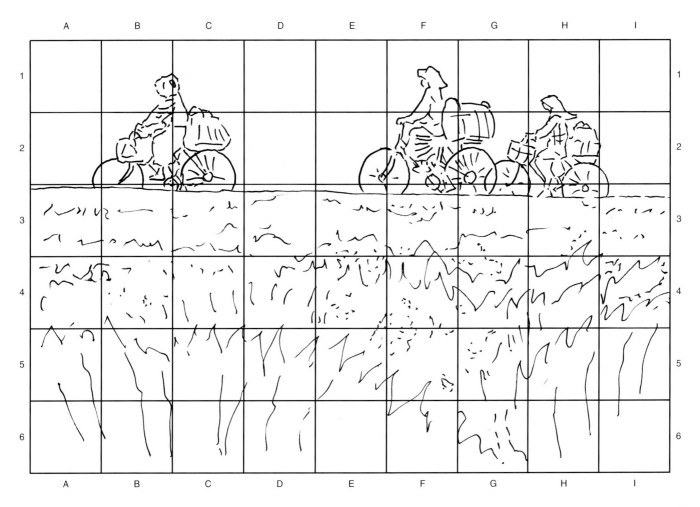

Study these pages before you start painting

Design and shape map
There is an intriguing gap between the first and second riders, but the second and third riders' bikes overlap slightly. This creates an interesting, yet natural, contour for the eye to follow. Notice how the vertical strokes of the grasses, as well as the vertical shapes of the cyclists, contrast nicely against the horizontal format.

Tonal value map
At first glance, the tonal plan of this picture may not be obvious. However, there is a distinct value shift from the lower band of grasses to the middle band. This subtle change creates depth and draws your eye up to the cyclists.

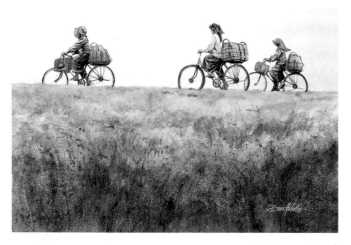

Detail guide
The cyclists are the stars of this show, so that's where all the action should be. The cloudless sky behind them makes them stand out. Some texture in the immediate foreground suggests it is closer to the viewer, creating a sense of depth.

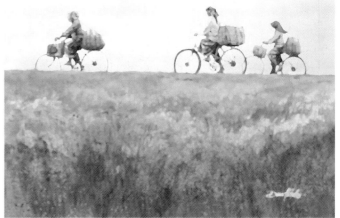

Color map (squint)
Overall, the painting is quite neutral, but a few touches of purer blues and oranges provide color harmony while giving the painting some extra pizzazz.

materials you'll need

paper
300lb (638 gsm) cold-pressed watercolor paper

brushes
2" flat

nos. 4, 8 and 12 rounds

grass comb (special brush with separated hairs)

other tools
2B pencil

table salt

spritzer bottle filled with water

old toothbrush

masking fluid

rubber cement pick-up

your palette for this painting

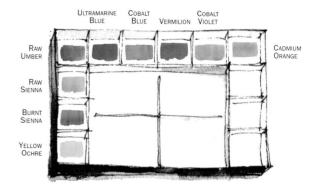

Ask yourself about the following elements

 Light source

The sun coming from behind the bike riders makes the sky very light. However, since there is still light falling all around them, they are not complete silhouettes. Plenty of detail is still visible in the figures.

 Viewpoint

Such a high horizon line is unusual, and therefore grabs a viewer's attention. It also shows off the great shapes of the cyclists.

 Bright idea!

Never discard an old, worn brush. Whether it's flat or round, you can go in with a pair of scissors and trim off some of the hairs, making it even more ragged than it was before. Now experiment to see what kind of interesting textures you can get from that custom-made brush.

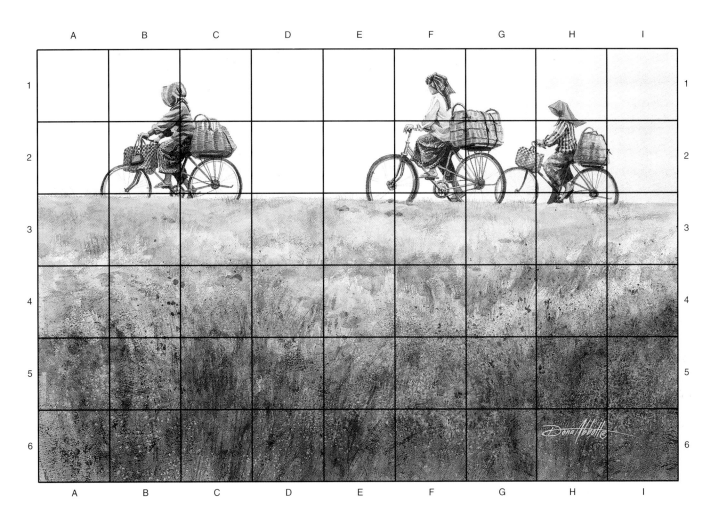

Techniques you'll use

- Preserving whites with masking fluid
- Large wet-into-wet washes
- Wet-on-dry painting
- Creating textures with a variety of methods

! Read me

Some days, it seems we have to rush through our activities so quickly that we don't have time to notice our environment. Slow down! As artists, we should always give ourselves the time and space to observe our surroundings and take note of potential subjects. That's how I discovered this outstanding subject!

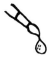 **Masking**

To preserve the whites use masking fluid to protect white and highlight areas. Using an old or inexpensive small, round brush, apply masking fluid over the middle rider's white blouse. Allow to dry thoroughly before continuing.

Putting it all together

4. Wash the sky

With a large, flat brush, wet the entire sky area with clean water. Then float in yellows, oranges and light blues, working left to right and warm to cool. Tilt the board to create soft, flat transitions between colors. You don't want any texture here that might detract from the figures.

5. Lay a base color for the grass

Wet the entire grass portion of the sheet with clean water. Then float in darker values of the same sky colors, remembering the value change between the middle ground and foreground horizontal bands. Vary warms and cools, adding blues to neutralize the orange tones.

6. Scratch and spatter

While this wash is still wet, create texture primarily in the immediate foreground by using a number of techniques. Sprinkle salt in some areas, and spritz clean water in other areas for variation. Use the hard, slanted tip of a brush handle to scratch in some long, vertical strokes in the foreground. As the wash dries, use an old toothbrush to spatter dots of purer colors and use a grass comb or ragged brush to apply long, swaying strokes of thicker Burnt Sienna and Raw Umber.

7. Start the figures

When the grass area has dried completely, remove all traces of salt before continuing. Next, go over each small shape within the figures and bikes, using small round brushes to paint a foundation color for each. As these colors dry, layer on deeper colors to create shading.

8. Add the details

When thoroughly dry, glaze on the details. Allow each glaze to dry before adding another color to prevent the colors from bleeding. Notice that most of the pure colors used are blue and orange, continuing the color harmony. Lift highlights by softening with clean water and blotting as needed.

Detail

Color learning point

By now, it's probably quite obvious just how useful complementary colors can be to an artist. Using two opposing colors side-by-side in a painting is guaranteed to add a lot of visual excitement and intensity to the work.

However, complements serve another great purpose in color mixing. The easiest way to tone down or neutralize the intensity of a bright, pure color is to mix it with its complement. Once you've mastered that, you can take your color mixes to a higher level by remembering your color temperatures. So, for example, if you want a green that's more neutral and cooler, add a cool red. If you want a green that's more neutral but warmer, mix in a warm red.

Detail

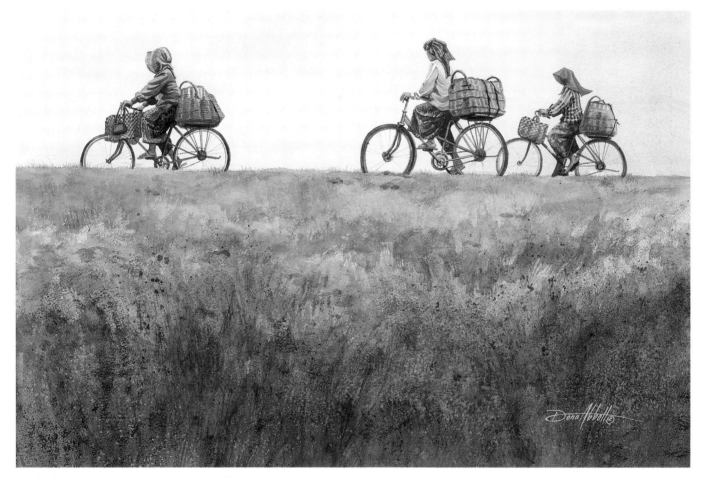

Cambodian Bikers — Market Bound, **watercolor, 17¹/₂ x 27" (45 x 68.5cm) by Dona Abbott ©**

Detail

Detail

Detail

art map 15

Harnessing the power of color

Before you begin, read the entire project through so you know what's going to happen next.

Who can resist the lure of a lighthouse on a windswept headland? There is something so dramatic and romantic about its majesty, especially when set against a stormy sky. With this picture, I wanted to capture the intensity of the storm and the sensation of the high winds on the landscape. It's fun to strive for a powerful, atmospheric effect.

As you can see, this final project is going to require you to mix some neutrals and to use some very dark colors. But thanks to the experience you've gained from the previous projects, you should be able to do this with ease. Don't be afraid to use lots of pigment and little water so that your painting is bold and attention-getting, not wimpy and wishy-washy. The complexity of the architecture will also require good brush control, but you can be free and loose with the sky and foreground.

My greatest hope is that I've taught you enough about color to know how to use it to your advantage in your own paintings. You can be bright when you want to demand attention, and you can be subtle when you want a gentler effect. I hope you've also learned how to design solid compositions that attract and hold your viewers' interest. Enjoy exploring these tools and techniques as you embark on this wonderful journey of discovering yourself through watercolor painting.

1. The image to be transferred using the art map.

Read the instructions to see how to map this image across to your paper.

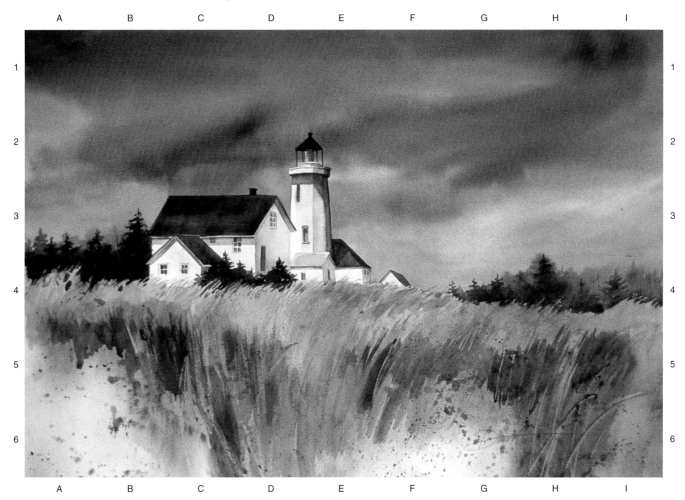

2. Mapping the image

With a 2B pencil, begin by LIGHTLY drawing a grid on your paper that has the exact same number of squares as my grid. Your paper can be the size of my original, but you may want to practice doing such a dramatic sky on a smaller piece before you go this large. This art map has 6 squares down and 9 squares across. Put in the letters and numbers along the edges to make the next step easier.

3. Use the art map to transfer the image

Now, still drawing very LIGHTLY with your pencil, copy the main contour lines of the objects as shown in each square onto your watercolor paper. It's not necessary to get every detail — just a simple line drawing will do. I recommend LIGHTLY and gently erasing the grid lines in the open, lighter areas before continuing.

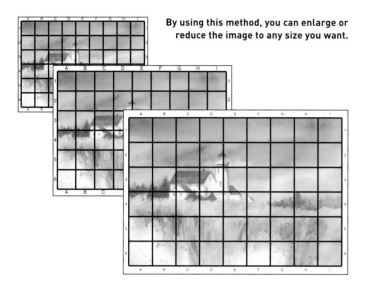

By using this method, you can enlarge or reduce the image to any size you want.

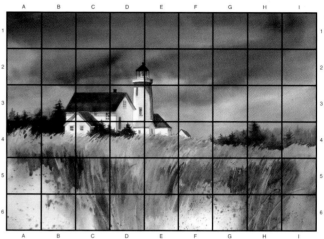

This is how your art map should look.

Here I've done the drawing quite heavily so you can see the idea, but you will do this lightly in pencil.

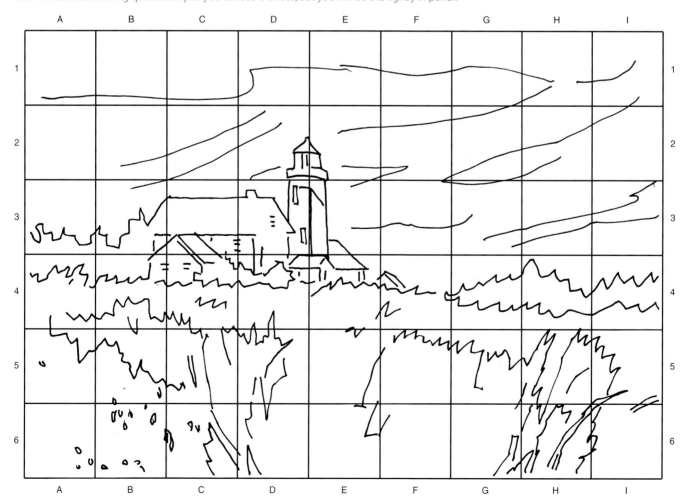

Study these pages before you start painting

Vanishing
point

Eye level
Vanishing
point

Perspective tips

If you're going to paint architecture, it's important to learn how to draw with correct perspective. The verticle corners of buildings always remain vertical, while lines that are horizontal in reality actually angle back in the drawing. All lines lead to two vanishing points positioned on the horizon line on either side of the structure. This is just a quick guide; I recommend studying perspective in greater depth by reading a good drawing book.

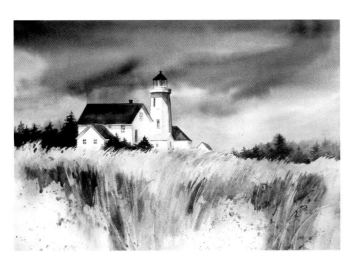

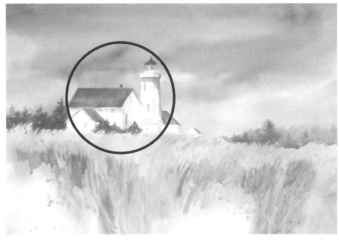

Tonal value guide

Values play an important role in conveying the windswept sensation of this painting. Notice how the dark clouds in the sky mimic the dark swaths of swaying grasses. Together, they sweep your eye around the painting, as if blown by the wind. The light spots in the foreground provide points of entry, while the dark spots anchor the painting.

Focal point guide

Where do you find the most extreme point of tonal contrast, the sharpest edges and the highest level of detail? That's right — the lighthouse is the focal point, effectively positioned near the upper left sweet spot.

materials you'll need

paper
300lb (638 gsm) cold-pressed watercolor paper

brushes
1/4", 1" and 3" flats
nos. 4, 8 and 12 rounds
fan brush
3/4" oval
rigger or script brush

other tools
2B pencil
spritzer bottle filled with clean water
old toothbrush
masking fluid
rubber cement pick-up

your palette for this painting

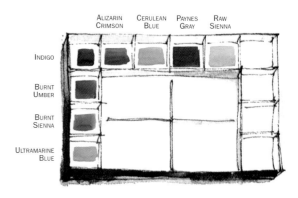

Alizarin Crimson · Cerulean Blue · Paynes Gray · Raw Sienna · Indigo · Burnt Umber · Burnt Sienna · Ultramarine Blue

Ask yourself about the following elements

 Light source

The angle of the light source is high and to the left. This puts the right sides of the buildings in shadow. Notice how the high angle also casts shadows from the overhanging roofs.

 Viewpoint

Some artists say you should never put the horizon line right in the center of the painting. What makes it work here? First, it's at an interesting angle. Second, the sky and foreground are closely intertwined through the use of color.

Bright idea

A lot of the texturizing techniques you will use are hard to control. As a result, you may get stray dots and spatters where you don't want them. To protect an area of the painting from these unpredictable techniques, lay a piece of plain white paper over the areas to be kept clean before you start.

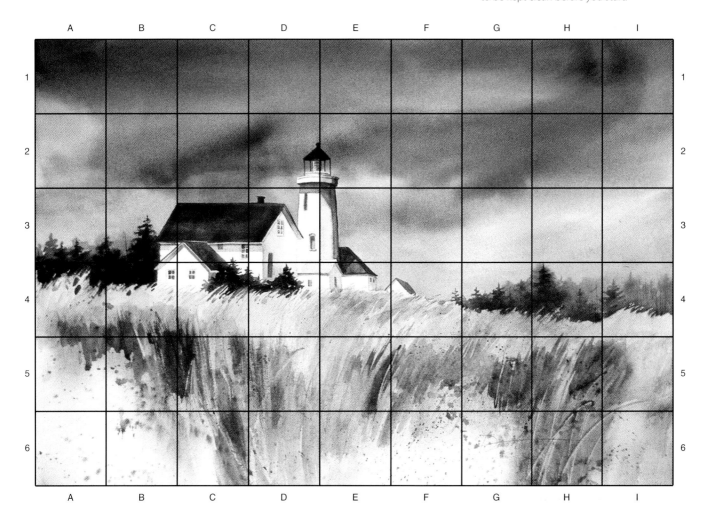

Techniques you'll use

- Preserving whites with masking fluid
- Large, graduated wet-into-wet washes
- Wet-into-wet painting
- Wet-on-dry painting
- Creating texture with spattering and scratching

 Beware

Texture techniques are a lot of fun to do, but as a result, they are often overused. I recommend using several techniques together so that the overall textured effect looks natural and convincing, not flashy or gimmicky.

 Masking

To preserve the whites use masking fluid to protect white and highlight areas. Using an old or inexpensive small, round brush, apply masking fluid over all of the buildings, including the cluster of trees in front. Let it dry completely before continuing.

Putting it all together

4. Paint the sky

With a large brush, wet the entire sky with clean water, right down to the edge of the grass. Using thick pigment and little water, sweep in mid-value strokes of Ultramarine Blue along the horizon, then add Paynes Gray, Indigo, Burnt Sienna and Burnt Umber for the clouds. Keep the movement of the clouds in mind as you lay down these strokes. Tilt the board to get these heavy pigments to merge and mingle. As the wash begins to dry, apply some mid-value Indigo with a little Burnt Sienna to create a backdrop for the distant stands of trees.

5. Sweep through the grasses

Before you continue, lay some plain scrap paper over the sky to protect it from flying paint. Next, wet the entire foreground with clean water. Float in Raw Sienna and Burnt Sienna, and touch in some blues, working around the two white areas. Spatter these same colors either with a toothbrush or by holding a pigment-loaded brush over the paper and tapping it gently against your other hand. Use the tip of the brush handle to scratch in grasses — watch their direction!

6. Add the background trees

Using a dark green mixture of Indigo, Burnt Sienna and Raw Sienna, apply the background trees on either side of the lighthouse.

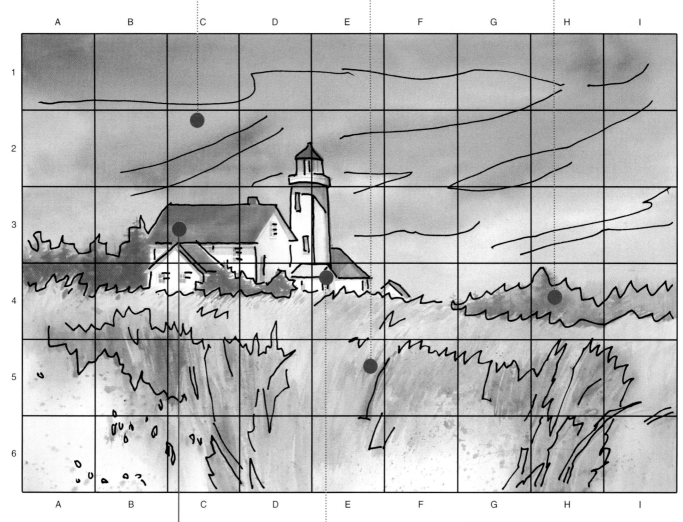

7. Paint the roofs

When the painting has dried completely, remove the mask from the buildings. Using varying mixes of Burnt Sienna, Burnt Umber and Alizarin Crimson, paint in the roofs. Use a small, flat brush and make short, drybrushed strokes to suggest (not define) shingles. Each roof shape should have subtle variations in value and color, and the roofs that are in shadow should have a more obvious shift in value.

8. Define the buildings

With the same basic colors used throughout, put in the shaded sides of the buildings and the cast shadows. When that has dried, you can wet the sunlit sides of the buildings and float in the barest hint of warm light. When all of that has dried completely, go back in with a very small brush to add the details. Be sure to vary the colors used for greater interest. As a final touch, go back to the dark green mix and add the trees just in front of the building to anchor that area.

Detail

Color learning points

This painting is bold and dramatic, stemming from the use of rich, dark tones. It takes some practice to learn how to get this level of intensity from watercolors without glazing, but you can do it. The secret is learning to use a lot of pigment and little water. A good rule of thumb is to dip the brush into water and shake it twice (like you would shake a thermometer), then dip it into the pigment. This is generally the right amount of water for most things.

You can, of course, achieve the same depth of color by glazing. But with that technique, you run the risk of losing some of the luminosity. If you want dark colors that still possess a rich, glowing look, try to achieve the correct values in the first pass as often as possible.

Also notice how the foreground grass colors are repeated in the sky and how the cloud colors are sprinkled throughout the grasses. As always, repetition leads to harmony.

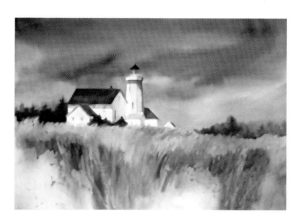

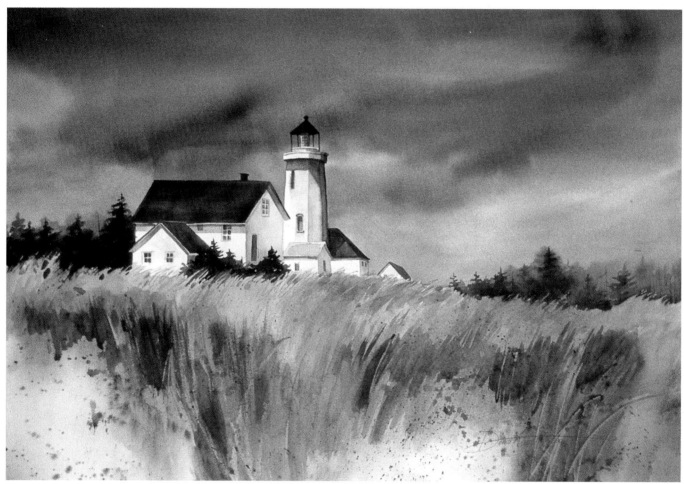

Beach Still Life, watercolor, 10 x 17" (26 x 44cm) by Dona Abbott ©

Detail

Detail

Detail

What artists want!

If you liked this book you'll love these other titles written specially for you.

Artist's Projects You Can Paint

Each of the 10 thrilling step-by-step projects in these books give you a list of materials needed and an initial drawing so you can get started straightaway, Dozens of individual color swatches will show you how to achieve each special mix. Clear captions for every stage in the painting process make these books a fun-filled painting adventures.

- **Artist's Projects**
 10 FAVORITE SUBJECTS IN WATERCOLOR
 By Barbara Jeffrey Clay
 ISBN: 1-929834-51-9
 Publication date: September 04

- **Artist's Projects**
 10 SECRET GARDENS IN WATERCOLOR
 By Betty Ganley
 Publication date: Spring 2005

- **Artist's Projects**
 10 WATERCOLOR TABLESCAPES LOOSE & LIGHT
 By Barbara Maiser
 Publication date: Spring 2005

- **Artist's Projects**
 10 EXPERIMENTS WITH IMPRESSIONISM IN OILS
 By Betty J. Billups
 Publication date: Spring 2005

Art Maps

Use the15 Art Maps in each book to get you started now!

Art Maps take the guesswork out of getting the initial drawing right, there's a color and materials list and there are plenty of tit-bits of supporting information on the classic principles of art so you get a real art lesson with each project.

- **15 Art Maps**
 HOW TO PAINT WATERCOLORS FILLED WITH BRIGHT COLOR
 By Dona Abbott
 ISBN: 1-929834-49-7
 Publication date: October 04

- **15 Art Maps**
 HOW TO PAINT WATERCOLORS THAT SHINE!
 By William C. Wright
 ISBN: 1-929834-47-0
 Publication date: November 04

- **15 Art Maps**
 HOW TO PAINT EXPRESSIVE LANDSCAPES IN ACRYLIC
 By Jerry Smith
 ISBN: 1-929834-48-9
 Publication date: December 04

- **15 Art Maps**
 MAPPING THE BEAUTY AND TEXTURE OF TREES IN OILS
 By David Wright
 Publication date: Spring 2005

How Did You Paint That?

Take the cure for stale painting with 100 inspirational paintings in each theme-based book. Each artist tells how they painted all these different subjects. 100 fascinating insights in every book will give you new motivation and ideas and open your eyes to the variety of styles and effects possible in all mediums.

- **100 ways to paint**
 STILL LIFE & FLORALS
 VOLUME 1
 ISBN: 1-929834-39-X
 Publication date: February 04

- **100 ways to paint**
 PEOPLE & FIGURES
 VOLUME 1
 ISBN: 1-929834-40-3
 Publication date: April 04

- **100 ways to paint**
 LANDSCAPES
 VOLUME 1
 ISBN: 1-929834-41-1
 Publication date: June 04

- **100 ways to paint**
 FLOWERS & GARDENS
 VOLUME 1
 ISBN: 1-929834-44-6
 Publication date: August 04

- **100 ways to paint**
 SEASCAPES, RIVERS & LAKES
 VOLUME 1
 ISBN: 1-929834-45-4
 Publication date: October 04

- **100 ways to paint**
 FAVORITE SUBJECTS
 VOLUME 1
 ISBN: 1-929834-46-2
 Publication date: December 04

How to order these books

These titles are available through major art stores and leading bookstores.

Distributed to the trade and art markets in North America by

F&W Publications, Inc.,
4700 East Galbraith Road
Cincinnati, Ohio, 45236
(800) 289-0963

Or visit: www.artinthemaking.com